IMAGES
of America

WAUPUN

To Gary & Karen,

Happy 175th Waupun!

Best Wishes,

Carla Dennis

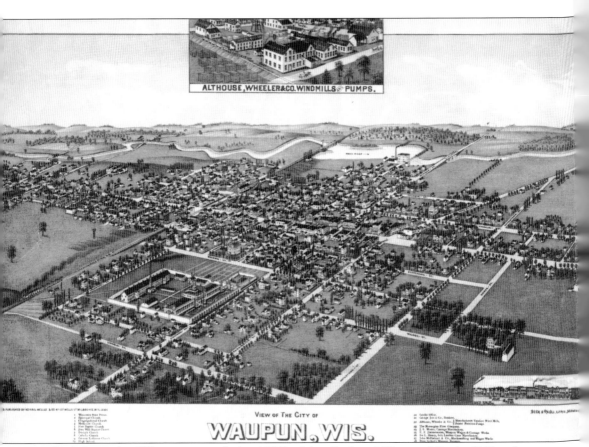

ALTHOUSE, WHEELER & CO. WINDMILLS & PUMPS.

VIEW OF THE CITY OF

WAUPUN, WIS.

This lithograph of Waupun was crafted in 1885 by Adam Beck and Clemens J. Pauli of Milwaukee. (Courtesy of the Wisconsin Historical Society.)

ON THE COVER: In 1928, Waupun hosted 50 school bands from all over the state for a band tournament run by the Wisconsin State Band Association. With over 4,000 people attending, it was the biggest band tournament ever held in Wisconsin at the time. Most bands arrived via train and were greeted with music and excited crowds. Entertainment started with a showing of the movie *West Point* at the Waupun Theatre. The event was held over the course of the entire week. (Courtesy of the Waupun Historical Society.)

IMAGES
of America

WAUPUN

Carla J. Gunnink and the
Waupun Historical Society

ARCADIA
PUBLISHING

Published by Arcadia Publishing
Charleston, South Carolina

Printed in the United States of America

Library of Congress Control Number: 2013942039

For all general information, please contact Arcadia Publishing:
Telephone 843-853-2070
Fax 843-853-0044
E-mail sales@arcadiapublishing.com
For customer service and orders:
Toll-Free 1-888-313-2665

Visit us on the Internet at www.arcadiapublishing.com

*This book is dedicated to the early pioneers and to all
the people of Waupun who have braved the good and
bad to make it the evolving city we see today.*

CONTENTS

ACKNOWLEDGMENTS

This book could not have been created without the expertise and assistance of the many people who supported me throughout the research and writing process. Unless otherwise noted, all photographic images are courtesy of the Waupun Historical Society. Jim Laird, the president of the Waupun Historical Society, provided invaluable assistance with his knowledge of local history as well as his own personal collection of images.

Thanks also go out to Rick Fletcher, Jay Graff, Bur Zuratsky, Frank Mesa, and Sheer's Photography for donating their knowledge, time, and photographic images. Thanks to the late June Kelly, who should be praised for her writings on Clarence Shaler and her detailed book on Waupun, *The First 150 Years, 1839–1989*. Also, Erwin F. Pfefferkorn preserved the history of Waupun's schools when he wrote *The History of Waupun Area Schools*. Both books can be found at the Waupun Heritage Museum and at the Waupun Library.

It is important to note that without the dedicated people of the Waupun Historical Society, both past and present, there would be very little preserved history for Waupun to celebrate. Stories of the past, once lost, are lost forever. My final thanks go out to the many Waupun residents who have donated and will be donating their treasured keepsakes so that future generations may enjoy them.

INTRODUCTION

For thousands of years, before the city of Waupun was a dream in the first settler's mind, the land was home to the Winnebago, Menominee, and Pottawatomie tribes, who inhabited the areas along the Rock River and Horicon Marsh. The Waupun area was located along an important highway route for the tribes, and, for that reason, it was closely guarded by them until they were removed to the west.

When Waupun was first settled by Seymour Wilcox, John N. Ackerman, and Hiram Walker in 1839, local Native Americans were a part of everyday life. It was said that Wilcox's wife, Lucy, allowed Indian women to use an upper room in their home to weave baskets during the cold winters. The Wilcox children played with the Native American boys and especially enjoyed watching them shoot their bows and arrows. However, pioneer life was not all play, and the days were often lonely and difficult. James McElroy, one of the first settlers himself, gave the following address to the Old Settlers' Club of Waupun in 1871, describing the first settlers: "They were not of that stripe of men who hang around the corners all day whittling dry-goods boxes and never have courage enough to get away from the end of their mothers' apron strings; but men and women who pitched their nightly tents on the broad prairie or under the spreading oaks, night after night, until they found a resting-place in Waupun . . . where they have labored to build up and improve the place of their choice and make it what it is today, the pride of its people . . . ever firm in the belief that there was before it a bright prospect of future usefulness and prosperity."

The first pioneers were a forward-thinking group who did well in farming the fertile land and developing new business opportunities to provide necessities to the growing population. In the early years, they used the Rock River, the lifeblood of the town, to ship their wheat and trade their furs with settlements to the south. The river was a major reason for Waupun's success as a center of agriculture and a mill town. These pioneering forefathers had the mindset of continued growth and success when they lobbied hard to bring the Wisconsin State Prison to Waupun in 1851. The town was chosen as the most suitable location due to the following facts, given by the state: the Rock Valley Railroad was to be run nearby, the village was abundant with limestone for building purposes, and it had easy access to pure water and reasonably priced lumber. Often referred to as "the prison city," Waupun has provided employment for many local citizens over the last 175 years.

After the Rock Valley Railroad made its first appearance on February 15, 1856, the importance of the Rock River as a connection for commerce declined. At this point, the little village was booming with industries and businesses, such as pump factories, wagon shops, carriage factories, plow shops, gristmills, and lumberyards. The town's successful growth attracted Eli Hooker and John H. Brinkerhoff to Waupun, and, in 1857, they printed and published Waupun's first newspaper, the *Waupun Times*. By 1866, the *Waupun Leader* had also been established. Waupun's history and the news of the time were now officially being recorded on paper. The intellectual minds of Waupun came together in 1858 to form Waupun's first library association, which was the second library association to be formed in the state of Wisconsin.

Due to Waupun's steady growth and peculiar geographical position in both Fond du Lac and Dodge Counties, a decision was made to establish a city charter in 1878. This charter did not solve the problem of being on the county line, which runs directly down Main Street and splits the town in half. The division caused a rivalry between the Waupun Dodge and Fond du Lac County school systems until 1900, when a union school was established, bringing the divided school systems together.

Waupun's culture grew through the years to encompass the blended settlement populations of Dutch, German, Norwegian, and Irish immigrants. Most came as farmers looking for land, but some settled in the city to develop businesses and services. Families were tight-knit and the celebration of family was key. Sundays were dedicated to the settlers' respective churches, businesses were closed, and most did not work on the holy day. Each group helped shape Waupun with its culture, customs, ingenuity, and religious beliefs.

Similar to many other small towns of America, Waupun lived its glory days between the early 1900s and 1929, when the Great Depression hit. In the mid-1920s, Who's Who in America listed no fewer than six Waupun-born men as outstanding leaders in their fields of achievement. Waupun was alive in the mid-to-late 1920s with a variety of industries, including Teeple Shoe Manufacturing Co.; Libby, McNeil & Libby Milk Condensery; Waupun Canning Company; and two hosiery companies: Bear Brand Hosiery (owned by Paramount Knitting Co.) and Vogue Hosiery. The land that was once lightly populated by Native Americans was now a vibrant city with strengths in agriculture, industry, service, and education. After the Depression, with the popularization of the car and the end of World War II, small-town Waupun slowly drained of its young people and the golden age waned.

Waupun started out as the dream of one man, Seymour Wilcox. His dream ended up fostering the dreams of so many others. Since its inception, Waupun has produced inspiring citizens who have established industries, built fields for aspiring baseball players, created larger-than-life photography, brought forth inventions that improved peoples' daily lives, treated the ill, and educated the children. One man, Clarence Addison Shaler, even created art sculptures just to share and donate to the city he cared for. Because of this generosity, Waupun has more sculptures per capita than any other city in North America. Each man, woman, and child who has gone to school here, worked here, and played here has left their mark on this town in some shape or form.

One

THE FOUNDING
OF A VILLAGE

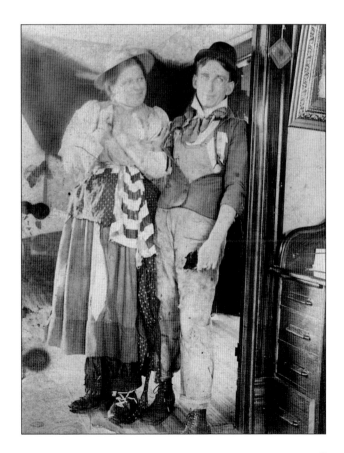

Lucy Mary Wilcox Margridge was the granddaughter of Seymour and Lucy Wilcox. She is standing on the left in this photograph dressed in raggedy clothes, possibly for one of the early plays in town.

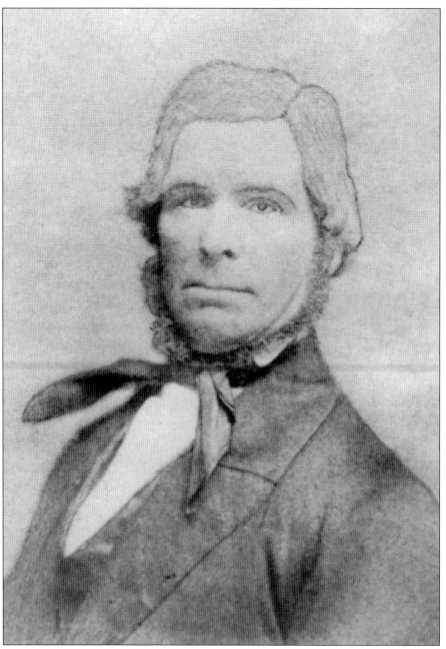

Seymour Wilcox was born on November 22, 1805, in the township of Madrid, New York. At the age of 23, he married Lucy Newton. They lived in a number of places as they began raising a family. In 1838, Wilcox traveled from Green Bay to find his own plot of land in the area known at that time as Oak Openings. He selected a spot for a home just east of Madison Street, near where the post office is located today. In the spring of 1839, Wilcox came back to Oak Openings with two single men, John N. Ackerman and Hiram Walker, who were inspired by his stories of beautiful fertile lands and an area of the Rock River they could utilize for power. The two men assisted Wilcox in building a log cabin that could hold all three men and Wilcox's family, who arrived by March 20, 1839.

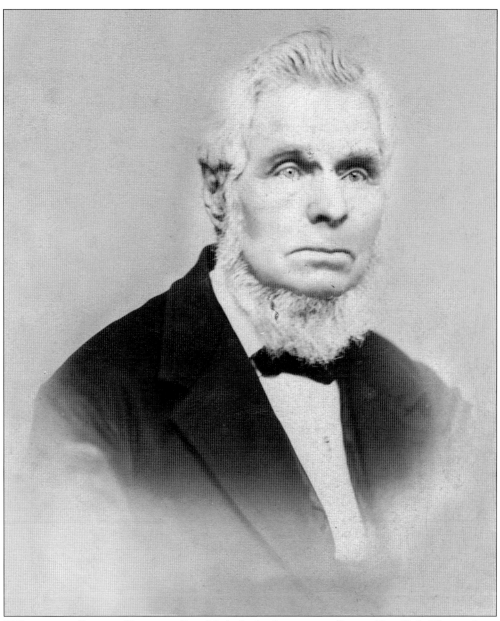

Wilcox originally named his new village Madrid, after his native village in New York. The southern portion of the village was to be called Waubun, meaning "the early dawn of day" to the Native Americans. When Wilcox received his first commission as postmaster, he was surprised to find that the name had been changed to Waupun by the Wisconsin delegate for Congress, James Dewayn Doty. It is unknown if the change was due to a spelling mistake or for other reasons. Wilcox never had the name corrected, and, by 1842, the township accepted the new spelling and Waupun was formally organized. Because of this, Waupun is unique in its name; there is no other city or town by the name of Waupun in the United States. By the time of its official organization, the village was thriving, with six settlers' families. Many of these first settlers had streets named after them. Seymour Wilcox died of paralysis on Friday, January 17, 1879. He is buried with most of his family in the Forest Mound Cemetery.

In 1828, Lucy Newton, at the age of 20, married Seymour Wilcox. The couple settled in Vermont, Lucy's home state, for a couple of years, where they had their first two children, Thurston and Hemon. The family moved to Canada in 1831, where they had two more children, Mary and George. They then moved to Green Bay, where they had a second daughter, Emily, and a boy, Nelson. Ira, their seventh child, was the first white male child born in Waupun. Tragically, the Wilcoxes lost their next two children at a young age. A baby boy, born on May 12, 1845, lived only four years, dying on February 24, 1849. A baby girl, Harriett M. Wilcox, was born on September 26, 1847, and died on May 2, 1850, just one year after her brother's death. Lucy lived until August 27, 1895, and is buried with Seymour in the Forest Mound Cemetery.

One of the first three men to settle Waupun, John A. Ackerman staked a claim in both Fond du Lac and Dodge Counties. He lived with the Wilcox family for three years until October 1842, when he married Hannah Ford. In 1846, Ackerman laid out 10 acres into village lots on the west side of town, calling it Upper Town. At around the same time, to the east, Seymour Wilcox began laying out 50 acres, which became known as Lower Town. Thus, a friendly rivalry began between the two men to determine which village would become the town proper. After Wilcox donated 20 acres of land to the State of Wisconsin to build the state prison, Upper Town reluctantly conceded. Ackerman was voted in as Waupun's first mayor after its incorporation, was twice village president, and was the justice of the peace for 20 years. He died in 1900 at the age of 87.

At the age of 11, Thurston Wilcox, the son of Seymour and Lucy Wilcox, became Waupun's first mail carrier. He made two trips a week on horseback, traveling from Fond du Lac to Portage. This photograph shows Thurston's house, which once stood approximately where the post office stands today. Every one of the Wilcox children built homes and lived on the Fond du Lac County side of Waupun, with the exception of Emily.

Hemon B. Wilcox, a Civil War veteran, was the second-oldest son of Seymour and Lucy Wilcox. Born in Vermont, he came with his parents to Waupun in 1839 at the age of nine. Hemon married his first wife, Esther Maxwell, in 1855. After she passed away in 1869, he married Nancy Silvernail.

Mary Caroline Wilcox, the first daughter and third child of Seymour and Lucy Wilcox, was born on February 17, 1833. She married DeWitt C. Brooks, who originated in New York. She passed away in Waupun on April 29, 1890. She and her husband are buried in the Forest Mound Cemetery.

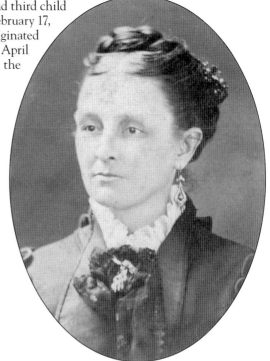

George Judd Wilcox was the fourth child born to Seymour and Lucy Wilcox, in Ontario, Canada, on January 14, 1835. He married Delia Carrington on January 14, 1858. According to census records, they lived at 418 East Franklin Street. George died in Waupun on June 14, 1920. He is buried with his wife in the Forest Mound Cemetery.

Ira Jason Wilcox (above, left), born on April 17, 1841,
was the first white male child born in Waupun and
the youngest surviving child of Seymour and Lucy
Wilcox. He married Angeline Middough (above,
right) in 1864 and they resided on North
Madison Street, near his sister Emily Wilcox
Houghton. After Ira's death on January 23,
1890, Angeline moved to Seattle, where
Emily was living at the time. Angeline
died in Seattle on October 31, 1931.

Magdelena Angeline "Lena" Wilcox Dodge was
the daughter of Ira and Angeline Wilcox and the
granddaughter of Seymour and Lucy Wilcox.

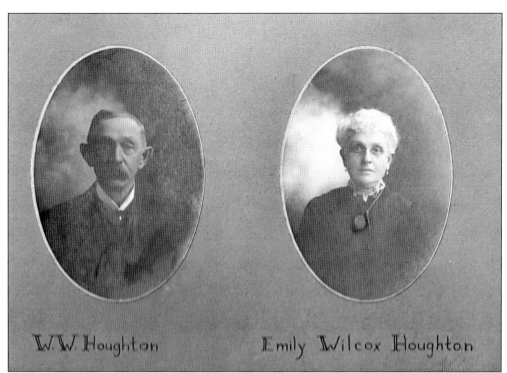

W.W. Houghton Emily Wilcox Houghton

Emily Janet Wilcox Houghton (above, right), born on April 2, 1837, was the fifth child and second daughter of Seymour and Lucy Wilcox. She married William Waldo Houghton (above, left) on November 14, 1859. They lived for some time at 129 North Madison Street, near her brother Ira. Emily and William moved to Seattle, where Emily passed away on August 16, 1905. She is buried in Mount Pleasant Cemetery in Seattle.

Lena Deora Morgridge Luck was the daughter of Lucy Mary Wilcox and George Morgridge, making her the great-granddaughter of Seymour and Lucy Wilcox, the founders of Waupun. Lena was a talented country singer in her younger years. In her later years, she served as the president of the Waupun Historical Society from 1971 to 1973 and worked hard to preserve and organize Waupun's history. She is seen here with her husband, Earl Luck.

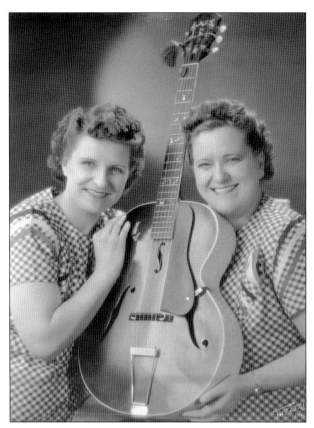

Anna Vaneitta (Morgridge) Wilson (left) and her sister Lena Deora (Morgridge) Luck were a country singing and comedy act on the radio from about 1938 through 1946. They performed in theaters and on the radio in Kentucky, Iowa, Illinois, and Michigan. They were also the great-granddaughters of the founders of Waupun, Seymour and Lucy Wilcox. They are seen here in 1944.

This Fourth of July parade float holds four generations of Waupun's founding family, the Wilcoxes. Grandson Earl Wilcox sits in the front seat; Lena Morgridge Luck, great-granddaughter, is in the back seat on the left; Agnes Hoard Bertsch, great-great-granddaughter, is in the back seat on the right; and Mari Bertsch, great-great-great-granddaughter, sits above and behind the others.

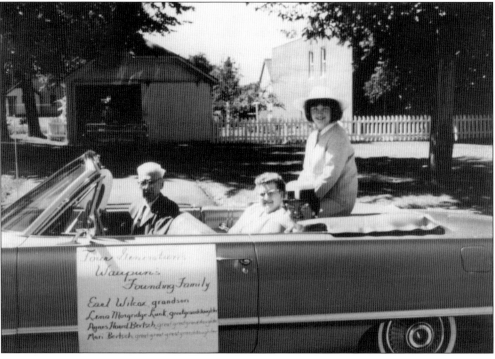

Two

DUTY CALLS

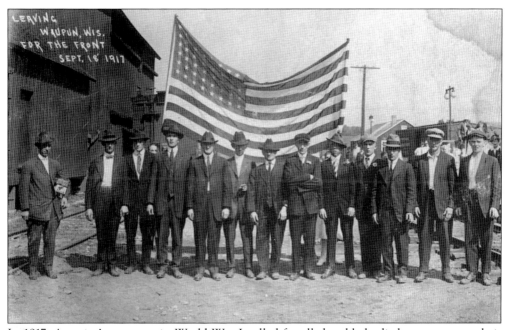

In 1917, America's entrance in World War I called for all the able-bodied men to serve their country. That included these brave men of Waupun, seen here just before leaving for the front lines on September 18, 1917.

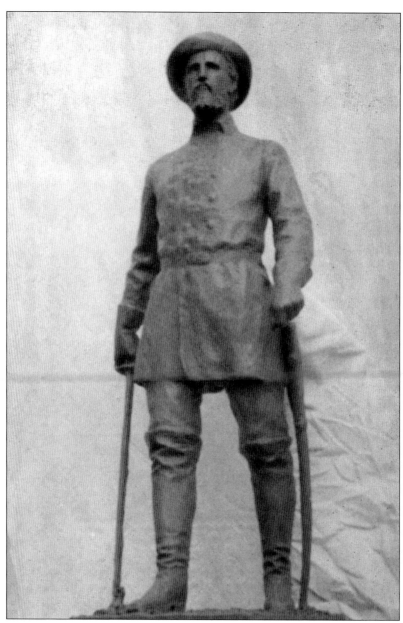

Col. Hans Christian Heg, born in Norway in 1829, was 11 when he moved to Wisconsin. At the age of 20, he joined the gold-prospecting "'49-ers" in San Francisco, but his father's death in 1850 brought him home to assume responsibility of the family farm. He married at age 22 and soon became a rising politician. In 1860, he was elected commissioner of the state prison in Waupun, serving there for two years. Under Heg's direction, there were many improvements made to the system. He believed that prisons should be used to "reclaim the wandering and save the lost." Heg's success as a recruiter, his passion for freedom, and his abhorrence of slavery helped win him the position of colonel of the 15th Wisconsin Volunteers during the Civil War. He proved to be a courageous and well-loved leader of the "Fighting 15th." Colonel Heg was shot during battle and died on September 20, 1863. The state of Wisconsin and Waupun mourned the loss of a great man and patriot.

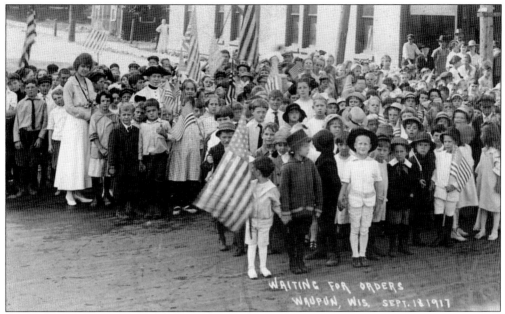

Everyone in Waupun gathered to be a part of the farewell celebration for the men called off to war. The young children were no exception; they are seen here waiting in a group to escort the departing men to the depot on September 18, 1917.

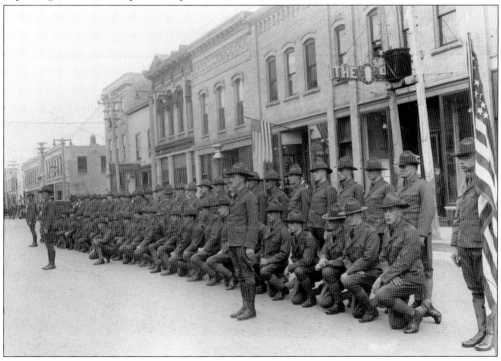

The Home Guard, established by the military, allowed men who did not meet the age or medical criteria for the military to volunteer as the protectors of towns and cities during World War I. The Waupun Home Guard is seen here in 1917 or 1918. The names of the members are available at the Waupun Heritage Museum.

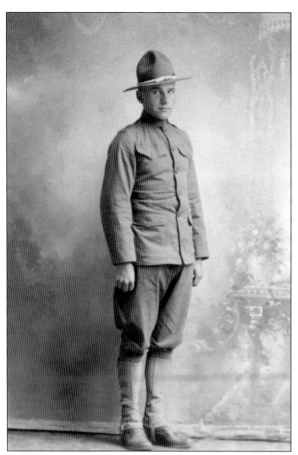

Helmuth H. Buckholz was born in Iowa on March 11, 1899. He was a soldier in World War I and moved to Waupun sometime after the war. After his death on April 6, 1960, he was buried in the Forest Mound Cemetery. The World War I uniform jacket he is wearing in this photograph is on display in the Military Room at the Waupun Heritage Museum.

Parades were held all over the country in September 1918 to support the fourth Liberty Loan and national drive for the American people to invest in Liberty Bonds supporting the Allied cause. The parade in Waupun was held on September 24, 1918, and the Home Guard is seen below marching.

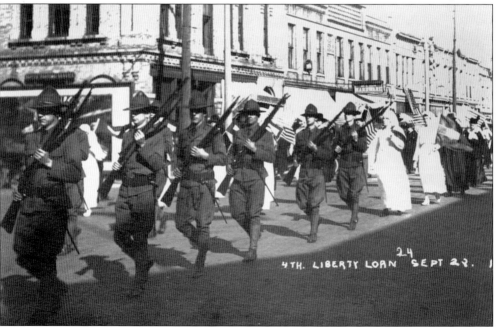

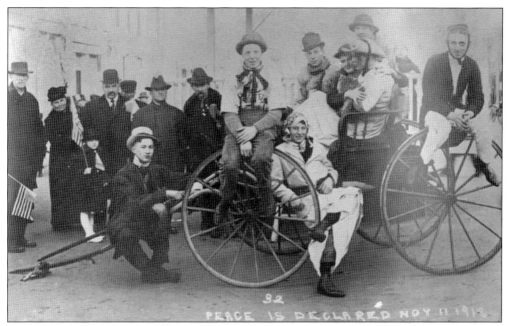

Waupun celebrated with the rest of the world on November 11, 1918, when Germany signed the armistice with the Allies, ending World War I.

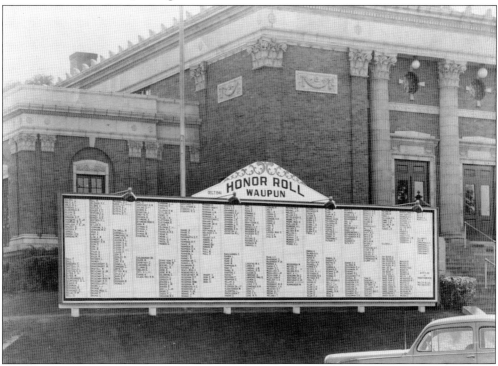

Through displays of honor rolls, Waupun has acknowledged the contributions of Waupun's men and women of the armed forces. This honor roll was dedicated in 1941. A photograph of the most recent honor roll dedicated to the veterans of foreign wars is displayed in the Military Room at the Waupun Heritage Museum.

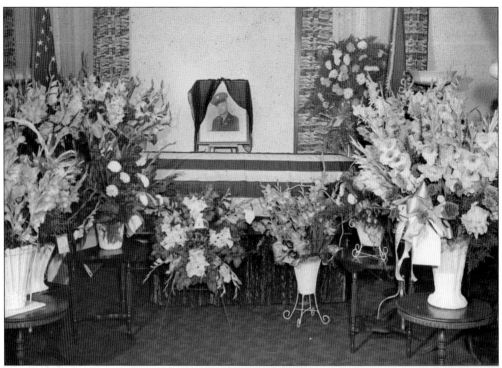

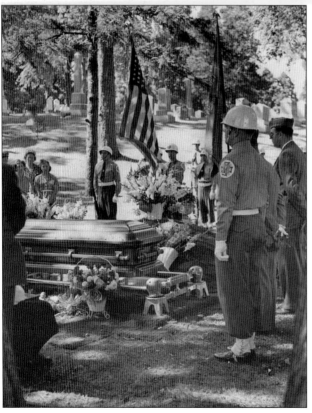

The Veterans of Foreign Wars (VFW) is a veterans' organization for those who have served in combat. Waupun's Bentley-Hull Post No. 6709 was chartered on May 5, 1946. It was named in tribute to the second and third Waupun residents killed in action during World War II. Leslie R. Bentley, a private in the Army, was the second Waupun resident killed in the war, on August 7, 1943, at the age of 23. Jerold Hull, a private first class Marine, was the third local resident killed, sometime after he went missing on November 20, 1943, at the age of 22. These photographs were taken by Fletcher Studio at the funeral of Private Bentley in the Forest Mound Cemetery. (Both courtesy of the Waupun VFW.)

The VFW Honor Guard was created to honor and recognize the passing of fellow veterans and military servicemen at their funerals. They also participate in parades and special ceremonies and offer presentations to schools on military and flag-folding etiquette. The Honor Guard for Waupun's Bentley-Hull Post is seen here in a Fletcher Studio photograph performing a rifle volley salute at the funeral of Pvt. Leslie R. Bentley.

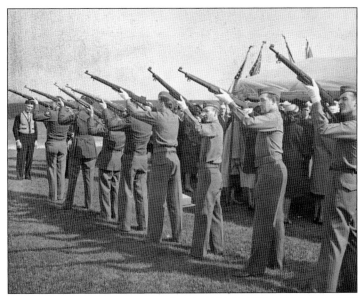

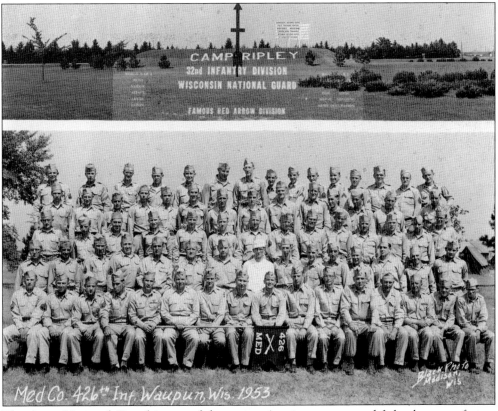

The Army National Guard is one of the country's primary state and federal reserve forces. Waupun's 426th Medical Company Infantry of 1953 belonged to the famous 32nd Red Arrow Division. During World War I, the 32nd spearheaded five offensive operations against German lines and broke through all five. This is what gave them the bar across the red arrow seen at the top of this photograph.

Henry Byron Landaal of Waupun was born on January 11, 1918. He joined the Navy Reserves in 1941, but was an ensign until he finished his medical degree. On April 6, 1943, he was appointed an assistant surgeon with the rank of lieutenant and sent to war. In June 1944, Landaal was killed during active duty. He earned a Purple Heart and a European African Middle Eastern Campaign Medal for his sacrifice and service to his country.

The American Legion Getchel-Nelson Post No. 210a was named for the first Waupun men killed in World Wars I and II, respectively. Lt. Daniel Getchel was the first local man killed during World War I, and Lt. Duane Nelson was the first to die in World War II. This photograph shows legion members standing with the employees of Libby, McNeil & Libby. Note that the flag only represents Lieutenant Getchel, meaning the photograph may have been taken before Lieutenant Nelson was added to the post's name.

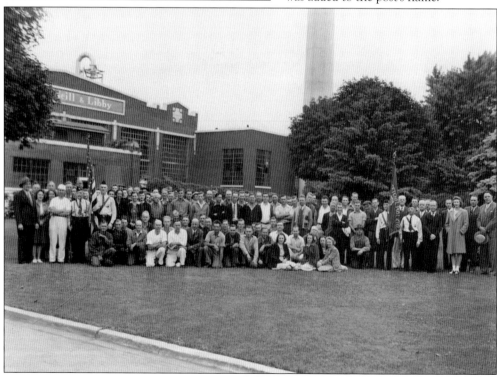

Three

CIVIC NEEDS

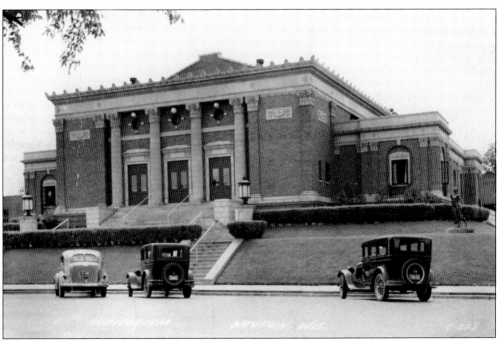

On January 21, 1925, the city council voted to appropriate $14,000 to purchase the site for a city hall. The chosen location was Baptist Hill, where the old Union Church was located on Main Street. The building was completed in 1928 in the Greek Revival architectural style, showcasing four Corinthian pillars. The grand opening to the public was held on Easter evening, April 8, 1928. The program was presented by five pastors.

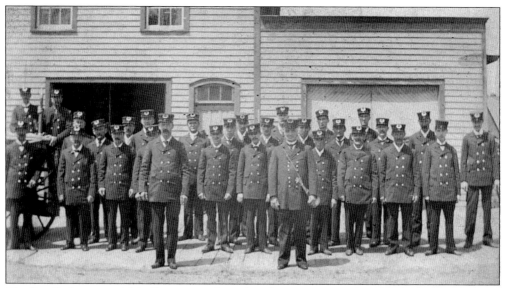

The first firehouse, on Main Street near the railroad crossing, was referred to as the City Fire and Band House. The Waupun City Band used the second floor for practice. A prominent figure in the early department was Edward H. Luck, who served with the volunteer fire department for 60 years and eventually became the chief in 1928. This photograph was taken in front of the original building in 1897.

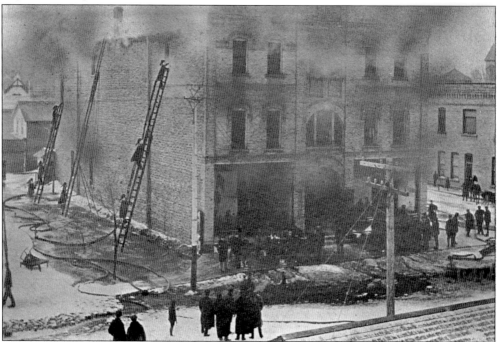

The first motion picture was shown at Whiting Hall, on the corner of Carrington and Main Streets, which is seen here in 1897. Since there was no electricity in Waupun at that time, management had to borrow an electric motor for the evening. Whiting Hall fell victim to this fire in February 1906. It was renovated and repaired after the fire and eventually became the Classic Theater. (Courtesy of Fletcher Studio.)

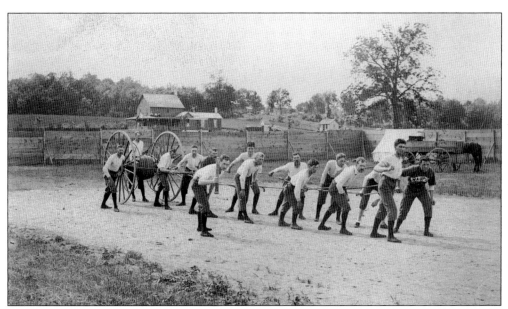

In 1871, after two years of heavy losses due to fires, W.G. Oliver financed the purchase of the city's first portable force pump hose, to put out fires too high to be reached by standard hoses. The Waupun Volunteer Fire Department is seen here practicing with a wheeled hose.

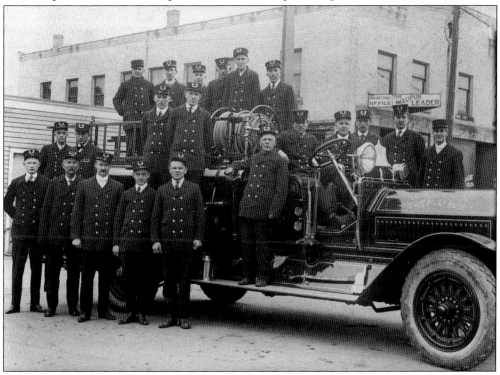

On October 6, 1874, the first official volunteer fire department was organized, with 45 men who signed up and agreed to become members without pay. That same year, the two-story City Fire and Band House was built to accommodate this Champion chemical fire engine, which had recently been purchased.

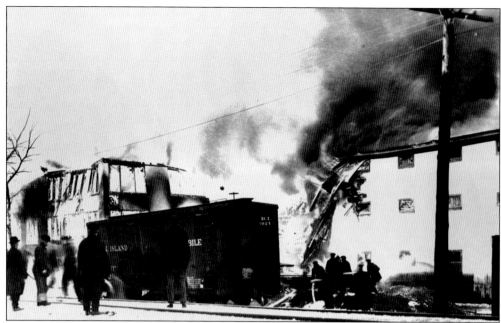

The citizens of Waupun witnessed a devastating scene on March 2, 1922, when the C.A. Shaler Company was struck by a horrendous fire. This fire destroyed all the buildings and most of the machinery, causing estimated losses of over $500,000 to the Shaler Company, $20,000 to the Althouse-Wheeler Company, and around $4,000 to the neighboring Beucus home. Although the losses of the buildings and the machinery were astounding, they did not compare to the loss felt by the families and friends of the three female workers who lost their lives in the fire. The victims, Bessie Koekoek, Mrs. Howard Carney, and Emma Michels, were all employees of Clarence Addison Shaler, who was in California at the time of the fire. After hearing of the fire, he wired officials to begin rebuilding the plant at once.

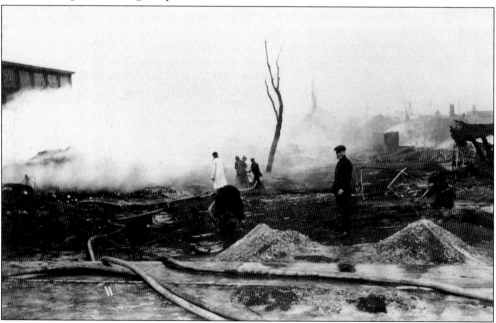

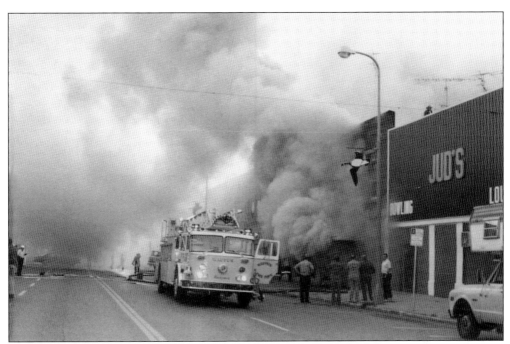

On September 7, 1977, Main Street was the victim of an uncontrolled fire. It began at the Meenk & Riel Building, just to the left of Judd's Bowling Alley, and quickly spread to Judd's. The Waupun Volunteer Fire Department arrived at the scene to control the fire as best they could.

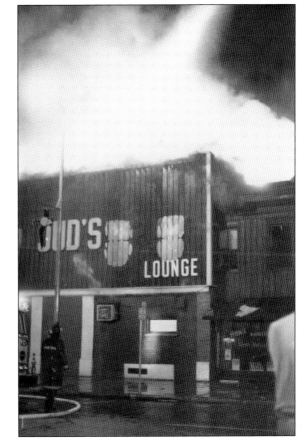

The building to the right of Judd's Bowling Alley was built in 1845 by Waupun's founder, Seymour Wilcox. Originally known as the Exchange Hotel and then the Beaumont Hotel, the historic building met its end when it was bulldozed to prevent the spread of the downtown fire of 1977.

The Waupun post office opened in 1840 in Seymour Wilcox's log house, with Wilcox appointed as postmaster. At that time, the US mail was carried on horseback from Fond du Lac to Portage once a week by Seymour Wilcox's 11-year-old son Thurston. Before the new post office building was constructed, the post office was located on the corner of Main and Mill Streets, on the first floor of the old opera house.

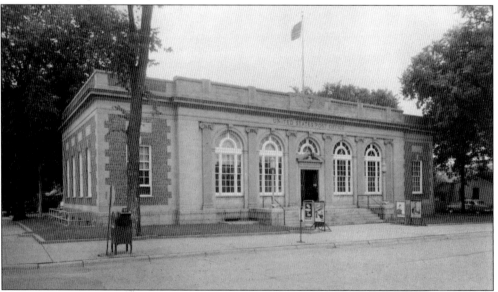

The first airmail letter was received by Godfrey Naumann on October 18, 1928. It was sent to him by his father, who mailed it from Germany on the *Graf Zeppelin* for $1. Five years later, on April 1, 1933, the post office moved into its new building, on the corner of Franklin and Madison Streets. It was designated a first-class post office and is seen here around 1960.

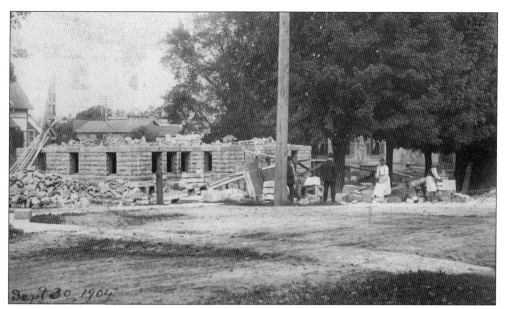

Waupun was the second city in Wisconsin to form a library organization, in 1858. It was operated as a private enterprise by Edwin Hillyer until 1890, when Waupun's city council took steps to have it established as a city library. In 1900, the local women's clubs raised $500 to make the library's resources free to the public. Burr Davis contacted Andrew Carnegie in 1903 to help win the city a grant to build a library in 1904.

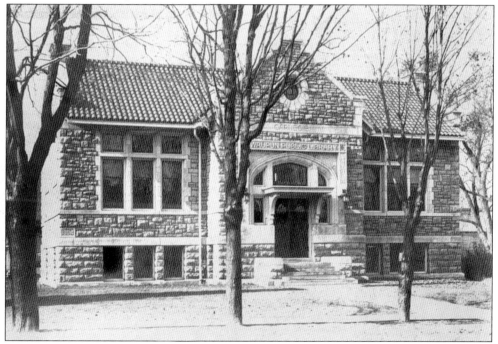

After winning a Carnegie grant of more than $10,000, the city bought the Hobkirk residence, at 22 South Madison Street, and developed it as the site of the new library. In August 1904, all 7,000 books belonging to the library were being worked on for classification. The cornerstone was laid on October 11, 1904, but the informal opening did not take place until October 21, 1905.

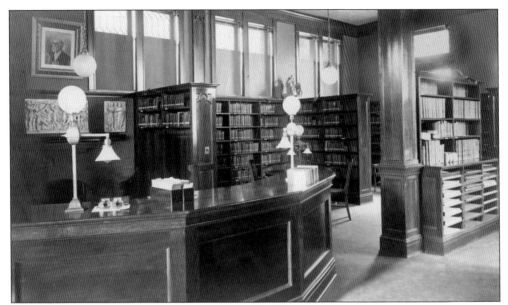

The Carnegie library served as the city library until the new library opened in 1968. For a couple of years, the building was home to the Educational Service Center for the school district, until the Waupun Historical Society leased the building in 1971. The society, as the keeper of the local museum, renamed the building the Waupun Heritage Museum. It was listed in the National Register of Historic Places in 1979.

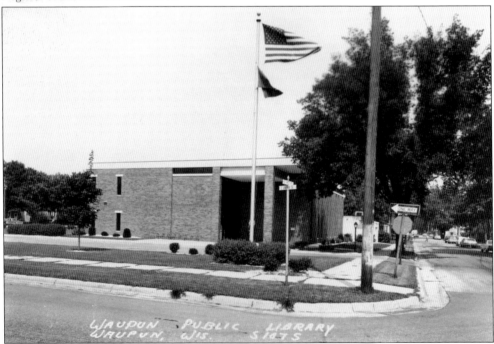

Eventually, the Carnegie library's space limitations made it inadequate. In 1965, a citizen committee appointed by the mayor selected the old South Ward school as the new site for the library. The city won a grant from the state to help cover some construction costs, and the opening ceremonies were held on June 22, 1968. The library has since been renovated and expanded.

Waupun's first school, built in 1844, was a log cabin located where the railway crossed Main Street. It was just large enough to hold 30 students. The first teacher was Charles Cleveland. The school also served as a community center and a religious meeting place. Seen here is one of the many small primary schools that popped up in the late 1800s to meet the demands of Waupun's growth.

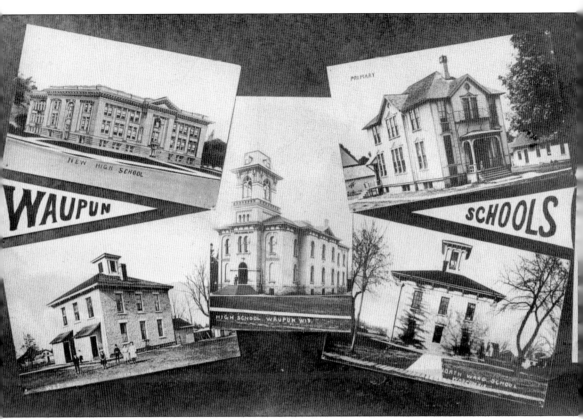

In 1853, the citizens of Waupun raised $1,000 to purchase land and build a two-room frame building for their new schoolhouse. By 1857, due to population growth, a new West Ward school was built with four classrooms. Because it was a private school, it was not considered a part of the Waupun district. In 1860, Waupun was divided into two counties, with the new Dodge County–Fond du Lac County border running down Main Street. Tensions ran high and the community had to decide whether Waupun should continue to have one school district or if two independent districts should be created. On October 12, a resolution was passed to split Waupun's school district down the county line and have two independent districts: the South Ward, in Dodge County, and the North Ward, in Fond du Lac County. This postcard shows the old schools of Waupun. The center photograph shows the old South Ward high school, which was later used as an elementary school until the opening of Washington Elementary School in 1954.

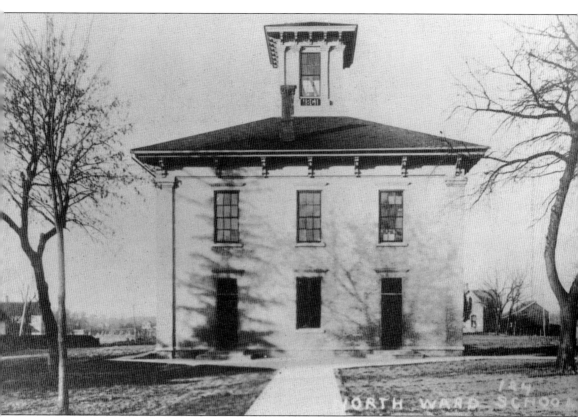

The division of Waupun into two school districts fueled an extensive and lengthy rivalry between the Fond du Lac and Dodge County school districts. Many had hopes for reconciliation to help improve both school districts, but nothing was done for 39 years due to the counties' unwillingness to cooperate. Even a state law passed in 1875 requiring Waupun to consolidate its schools did not bring the districts together. Waupun continued to violate the state law until 1898, when it passed the problem on to the state superintendent, who ruled that the North, South, and West Wards had to unite under one district to create a unified Waupun High School. The North Ward school is seen here.

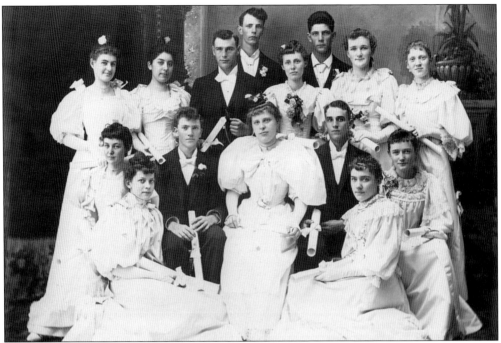

The South Ward graduating class of 1898 is seen here. Frank Fletcher, the father of Ervin Fletcher of Fletcher Studio, stands third from the left in the third row. Just two years later, the class of 1900 was the first class to graduate from the newly combined Waupun High School, which was housed in the former South Ward school.

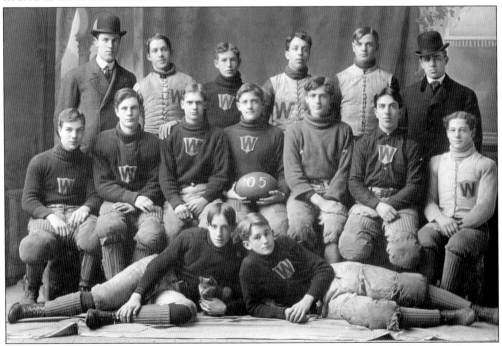

Records show that the 1905 Waupun High School football team, seen here, defeated Berlin 11-0. The class of 1905 presented the school with a drinking fountain as its class gift.

In 1927, the Waupun High School football team, seen here, won its second consecutive championship in the Little 10 Conference. Waupun's odds of winning the championship increased after their biggest rival, Watertown, dropped out of the Little 10 to play in a more competitive conference. (Courtesy of Jim Laird.)

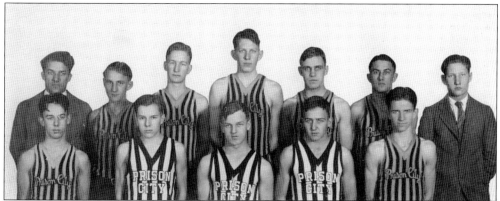

In 1926, the Little 10 Conference was organized with Berlin, Ripon, Waupun, Horicon, Mayville, Beaver Dam, Portage, Hartford, Columbus, and Watertown. The next year, Oconomowoc and West Bend took the spots of the departed Watertown and Portage. The 1928 Waupun High School basketball team, seen here, took second place in the Little 10. Note that their jerseys read "Prison City." (Courtesy of Jim Laird.)

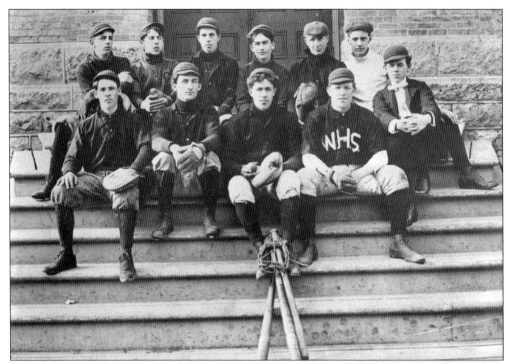

One of Waupun's old baseball teams poses for a photograph around 1900. At one time, Waupun's school colors were purple and gold. It is unknown when the colors changed to black and gold; however, due to the early date of this photograph, it is possible that these players were wearing purple in their uniforms.

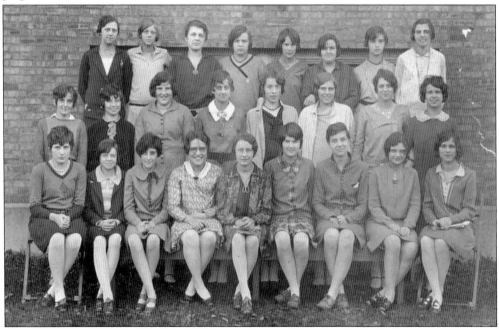

The 1929 Waupun High School Senior Girl Glee Club posed for this photograph outside the school. The choral group specialized in singing short songs, or "glees."

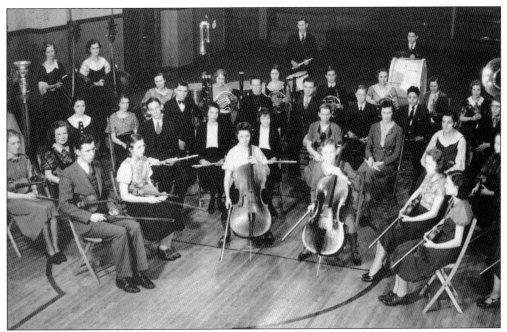

In 1933 and 1934, the Depression hit everyone, including the schools, which saw their staff members receive pay cuts from 15 to 30 percent. Funds for special activities were also cut, with the exception of the popular music program. Waupun High School not only had a marching band, it also supported this orchestra, which featured violins, cellos, French horns, tubas, and even a contrabassoon, played by Ervin Fletcher, who is seen here just left of center in the black bowtie. (Courtesy of Fletcher Studio.)

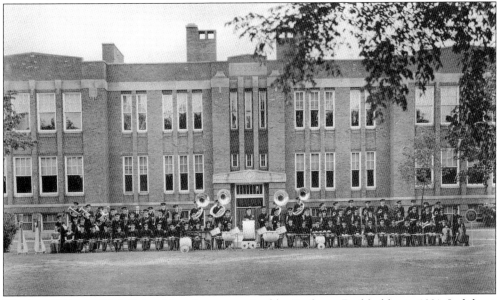

The first Waupun High School band was organized by Professor Burkholder in 1921. It did not compete in its first year; however, in its second year, under new band director Mr. Nealy, the band won second-place honors at a tournament in Two Rivers. This photograph was taken in front of the 1913 Waupun High School building, which became the junior high school in 1963.

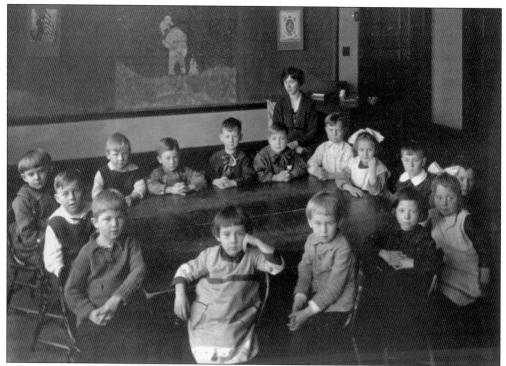

Lincoln Elementary School, at 965 Wilcox Street, was completed just in time for the beginning of the 1917 school year. Seen here is the Kindergarten class of Miss Rogers. Seated front and center with her hand to her cheek is Harriet Getschel. Ervin Fletcher is seated in the back row of four boys, the first boy on the left. (Courtesy of Fletcher Studio.)

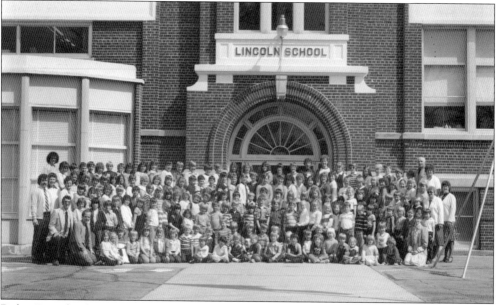

Before Lincoln Elementary School was built in 1917, the West Ward school was used as the grade school. Lincoln, which had an addition built in 1938, is seen here with the last students and faculty who used it before it was closed and torn down. (Courtesy of Fletcher Studio.)

In 1952, it became evident that the 80-year-old South Ward school was no longer in satisfactory condition to hold students. The district voted to build a new grade school on the east side of town. The *Leader News* sponsored a contest to name the new grade school in 1953. The new Washington Elementary School, seen here, opened the following year.

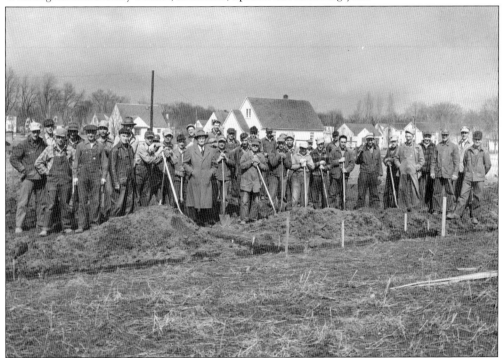

In 1944, with only $300, the Christian Reformed Church procured property for a Christian grade school at the corner of Beaver Dam and McKinley Streets. This photograph shows the ground breaking ceremony for the new building. The three-room structure opened its doors in 1949; by 1969, it had grown to include eight rooms, a gymnasium, and a kitchen. In response to the demand for a Christian education beyond elementary school, a Christian high school was built in 1958.

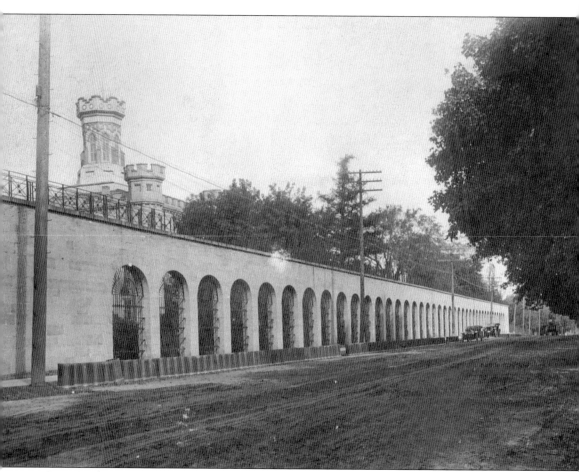

In 1851, the state legislature appointed a board of commissioners to select a location for the Wisconsin State Prison. The commission considered Madison, Portland, Genesee, Horicon, Kaukauna, and Waupun. Eli Hooker spent several months in Madison serving as Waupun's lobbyist and, in doing so, was forced to postpone his wedding. It was worth the effort, because on July 4, 1851, it was announced that Waupun had been selected as the site of the new prison. The commission cited several reasons for this decision, including the abundance of limestone, wood, and water in the area and the fact that the Rock Valley Railroad was planned to run through Waupun. It also helped Waupun's chances that the founder of Waupun, Seymour Wilcox, donated 20 acres of his own land on which to build the prison. This photograph was taken from Madison Street in 1915.

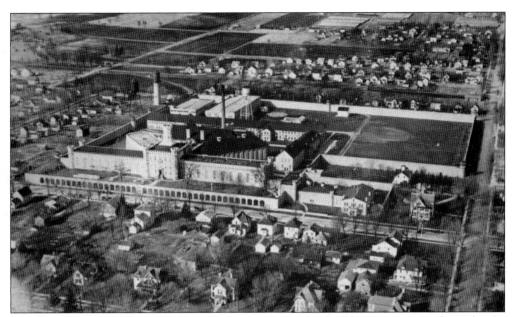

The first temporary Wisconsin State Prison was a wooden building approximately 26 feet by 80 feet. By 1852, the building housed 24 men, 2 women, and a 12-year-old boy. In 1861, the foundation for the stone wall was almost complete; the workshop and chapel had been built a couple of years prior. In 1855, a contract was entered into for employing convict labor. Men in the tin shop made 48¢ per day, shoe shop work paid 60¢ per day, and carpentry work paid 55¢ per day. In 1867, regular schoolwork was organized and run by the prison chaplain. Prisoners helped construct the building, which was completed in 1868.

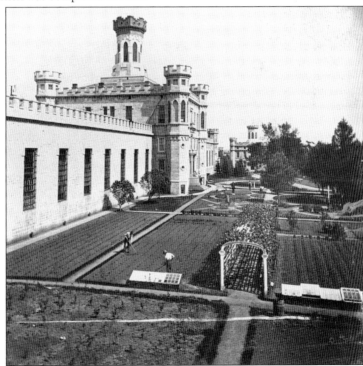

The Wisconsin State Prison garden was kept by both the female and male prison population of the time. This photograph of the garden was taken by Andreas L. Dahl between 1873 and 1879. (Courtesy of Jim Laird.)

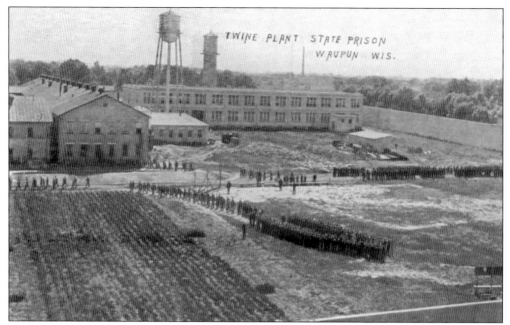

In the early 1900s, every inmate was required to work in one of the prison's industries or daily operations. These inmates produced shoes, license plates, clothing, and binder twine. The hemp mill on the prison property was the largest industry operated by the state. The factory employed 80 inmates and produced about six million pounds of binder twine per year. In 1916, the mill showed a profit of $86,217, making the prison self-sustaining for the first time in its history.

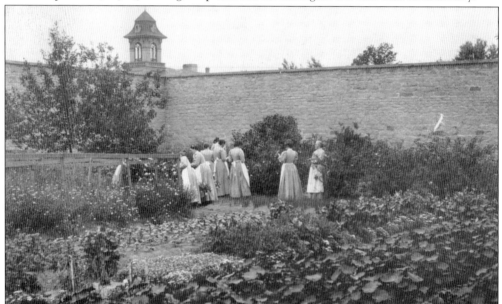

In 1857, the state built a school building to house the young boys being held in the Wisconsin State Prison. Unfortunately for the women, they were not separated in their own section of the prison until 1862. Finally, in 1933, the state built a prison in Taycheedah to house the female prison population. This photograph shows female prisoners tending to the prison garden in 1898. In the background is the South Ward tower. (Courtesy of Jim Laird.)

At one time, the Wisconsin State Prison was considered part of the local tourist industry. People would visit from all around the state just to get a glimpse of what went on behind the walls. Tourists were instructed not to point out, attempt to converse with, stare at, or pass anything to an inmate. The tours were a dangerous practice and were discontinued in 1940. A group of tourists is seen here on the front steps of the prison in the 1880s.

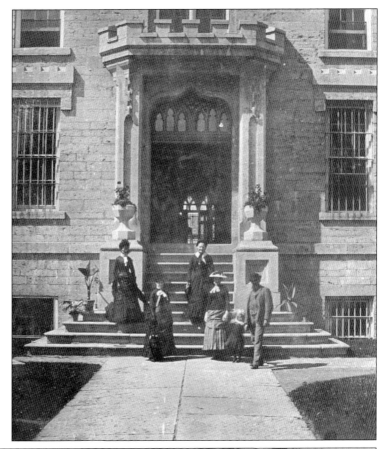

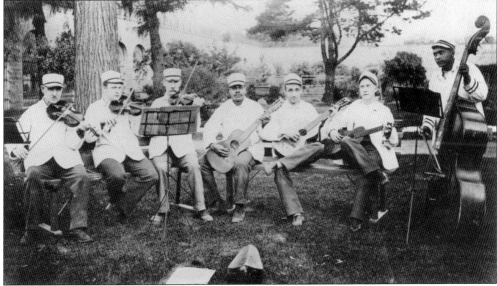

In 1908, there was a prison population of 655, with 23 females. That same year, the prison band was first organized. Band concerts were given on Monday evenings during the summer in the front yard of the prison. Seen here is one of the prison's early musical groups.

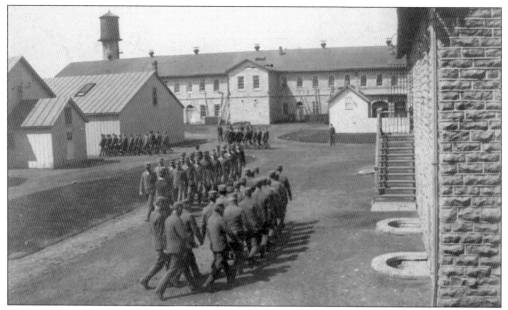

In the early years of the prison system, there were many restrictions on the inmates. The silent system was a rule mandating that inmates not speak with anyone unless otherwise instructed. This rule was in effect even during mealtimes and at work. Other restrictions for the prisoners included no shaving, no smoking cigarettes, and no exercise anywhere but in their individual cells. This 1905 photograph shows the typical routine of prisoners—lined up, looking forward, and silent—as they travel about the prison grounds.

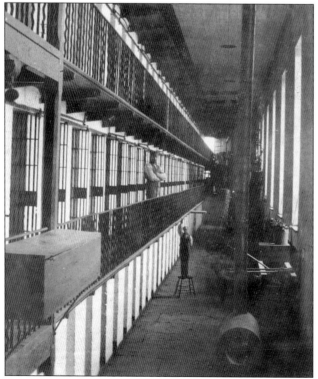

Many changes occurred when John C. Burke took over as warden in 1938. A public address system was installed and prisoners began enjoying both educational and entertainment programs. In the same year, the prison replaced the old straw-filled mattresses with cotton mattresses and the 25-watt lightbulbs with 40-watt bulbs to prevent the prisoners' eyes from going bad while reading, writing, or studying in their cells.

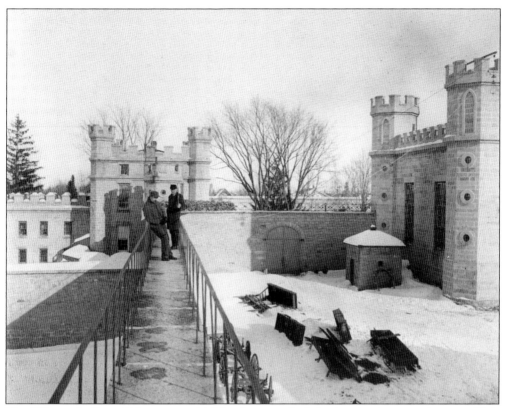

The Wisconsin State Prison was a highly photographed destination in its early years. This photograph was taken in 1893 by P. Lecher of Milwaukee. (Courtesy of Jim Laird.)

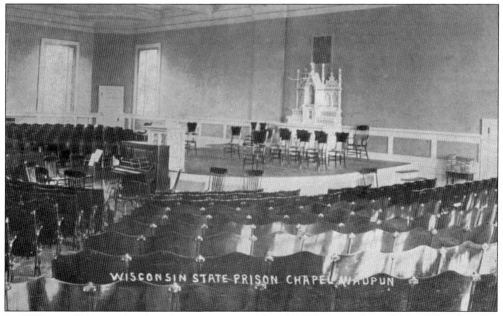

In 1859, a workshop and a chapel were constructed at the Wisconsin State Prison. The chapel is seen here on one of the postcards that were sold during tours of the prison.

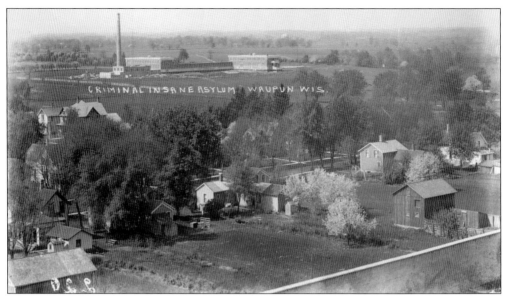

Wisconsin recognized the need to care for the criminally insane, so on January 12, 1914, it opened Central State Hospital for the Criminal Insane. The institution, located on West Lincoln Street, later changed its name to Central State Hospital. Thousands of individuals were cared for during the 69 years of its operation. Central State closed its doors on April 14, 1983, and its last patients were transferred to Mendota Mental Institution in Madison. (Courtesy of Fletcher Studio.)

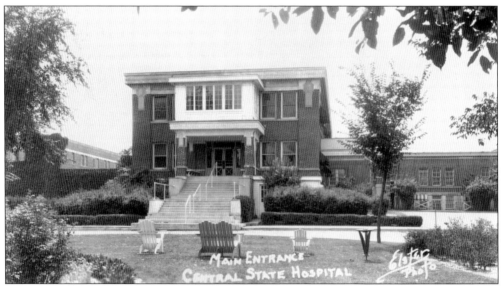

Dodge Correctional Institution (DCI) received its first inmates on May 15, 1978, when the decision was made to begin turning the outdated mental institution into a modern correctional facility. Dodge Correctional is the first place an inmate goes when entering the Wisconsin penal system. It is Dodge's role to assess and evaluate all adult male inmates entering the system. The main entrance of the facility is seen here before it became DCI.

Four

THE ROAD TO PROSPERITY

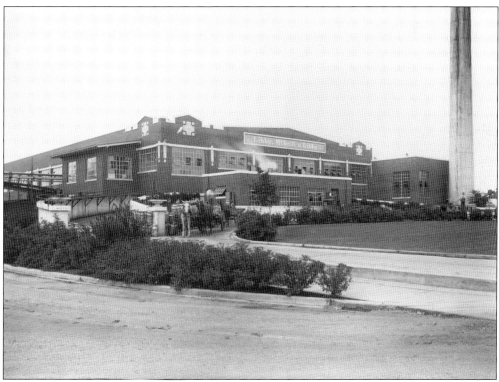

Libby, McNiel & Libby, a manufacturing plant based out of Chicago, consisted of three different departments: a milk condensery department, a tin department, and a wooden box factory. The milk department canned about 250,000 cans of evaporated milk daily and the tin department had an output of nearly half a million cans. They were eventually bought by Carnation Company in the 1940s; by the 1980s, Nestle bought Carnation. In 1987, the plant was purchased by the Silgan Corporation. (Courtesy of Rick Fletcher.)

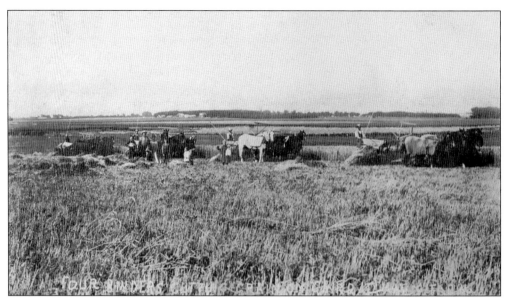

Wheat farming was an important industry in Waupun's early development. The first settlers found prosperity in this crop, and the outlying wheat farms contributed to the young city's growth and progress. After the railroad reached the community in 1856, Waupun became the second-largest wheat producer in Wisconsin. This photograph shows local farmers cutting wheat grain for harvest with their binders and four horse hitches. (Courtesy of the Waupun Historical Society; donated by Gerret Navis.)

The first wagon manufacturer in Waupun, Wells, Archibald & Co., began operation in 1853. By 1864, Thomas Oliver began manufacturing steel plows. This photograph captures the delivery of new Jones Lever Binders to the Beichl & Kluegel agricultural warehouse on June 13, 1896. The warehouse was owned by Charles Beichl and Benjamin Kuegel. These binders were grain harvesters that bundled and tied grain crops for farmers. This building later became the Landaal Brothers John Deere farm implement shop in 1903.

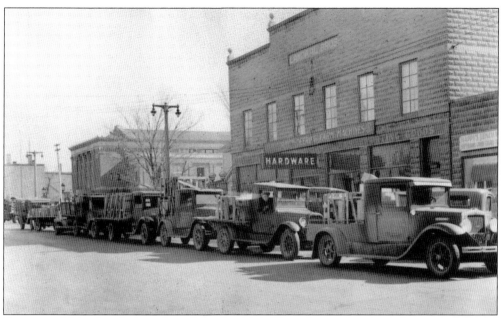

George and John Landaal purchased the Beichl & Kluegel agricultural warehouse in 1903 and renamed it the Landaal Brothers Farm Implement Company. They replaced the original wood-frame building with a brick building, which still stands and is currently the home of the accounting firm Westra, Tillema & O'Connor. This photograph was taken in 1933. Just to the right of the Landaal building is a sign that reads "Happy's Lunch Room: Soft Drinks, Candy, Cigars, and Tobacco." (Courtesy of Wisconsin Historical Society.)

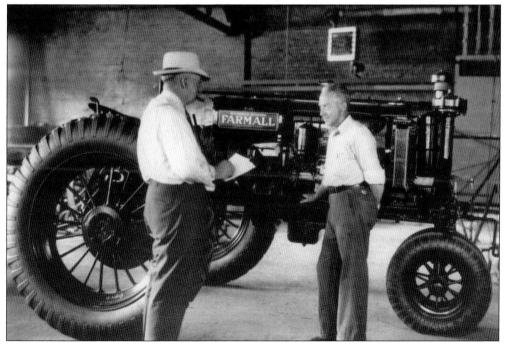

George Landaal (left) shows a Farmall F-20 tractor to a customer in the Landaal Brothers showroom. (Courtesy of Wisconsin Historical Society.)

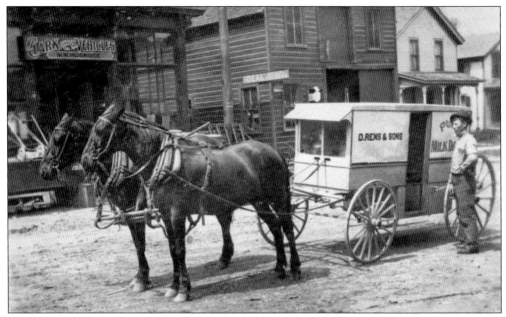

Dairy production has been an important part of Waupun's growth since the town's inception. In 1894, a group of local farmers from Alto and Waupun banded together to market their milk. They named their entity Alto Dairy Cooperative, and it has been member-owned since its inception. Today, it is an industry leader in the production of cheese. This photograph shows the D. Rens & Sons milk delivery truck. (Courtesy of Jim Laird.)

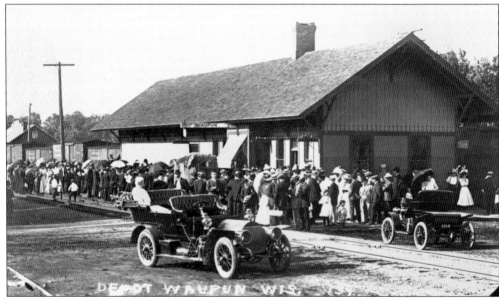

In 1853, a railway was to connect Milwaukee and La Crosse. Waupun was presented with the opportunity to be a part of the railroad, but most locals were disinterested because of the requirement that they purchase stock. Two people, William Ewen and Edwin Hillyer, worked hard to convince the people of the railroad's value. The determination of these individuals brought the railroad to Waupun on February 15, 1856, at 11:30 p.m., just shy of the midnight deadline, which saved the company $40,000.

Milo J. Althouse, originally a well driller, later became interested in the Waupun vaneless windmills invented by Albert and George Raymond. Althouse bought the patent rights to the windmills in 1874 and, within a decade, established a firm with George Foster Wheeler called Althouse-Wheeler & Co. These windmills were manufactured by the thousands until the mid-1930s, when the company was bought out by Milfound Company.

Althouse-Wheeler & Co. exported its windmills all around the world, to places like Australia, New Zealand, and South Africa. In the 1920s and early 1930s, it was the job of William John Konings, seen below with his son, to take the windmill displays to fairs for promotion and demonstration. Konings said the Fond du Lac County Fair was his favorite fair to attend each year.

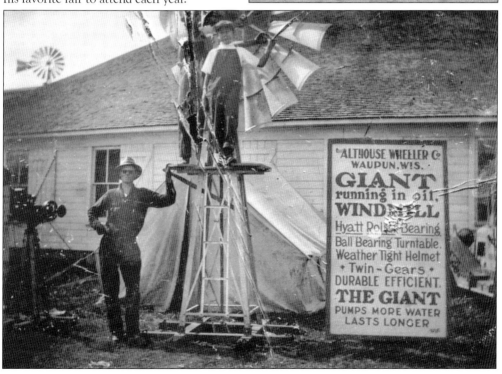

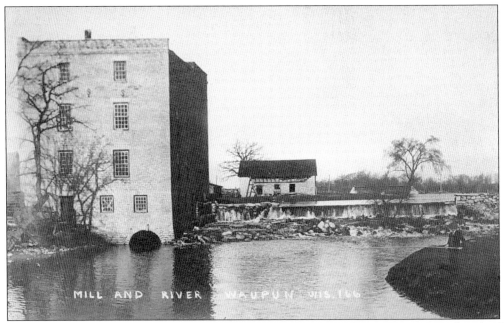

The first sawmill was built in 1841 by Minus Collins and W.G. McElroy in Upper Town (north of Main Street), at the dam seen here. Although the original mill was made of only wood, it was a great undertaking in those early years. The stone mills seen here were constructed in 1849 by mill owner William W. Harris. The complex later became a foundry. The stone mills used waterpower to make rakes, cradles, tables, and chairs. This photograph of the mill was taken around 1915 by Alfred Stanley Johnson.

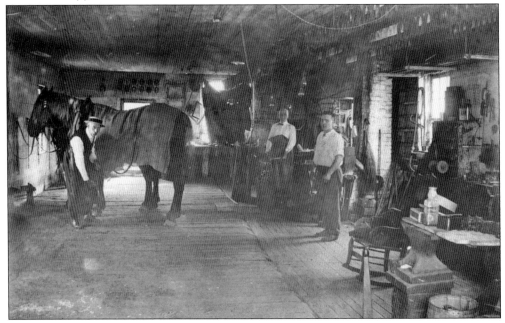

Blacksmith shops were greatly needed in the early years. Seen here in a blacksmith shop are, from left to right, Albert Henry Luck (the uncle of Victor Hass), Prentice Carrington, and Ned Lindsley. (Courtesy of Jim Laird.)

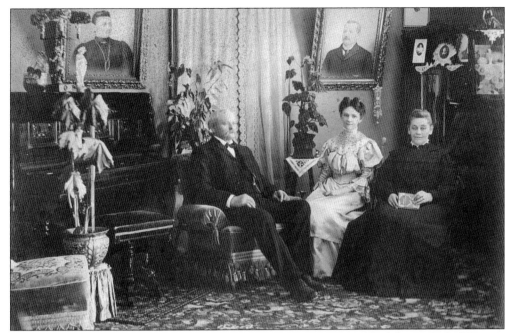

Around 1850, before there were refrigerated railcars, the only source of fresh beer was the Waupun Brewery. Originally located on Main Street near Brandon Road, the brewery was purchased by Peter Seifert in 1876. Seifert operated the brewery for 18 years until it was sold to John Skala in 1894. Skala relocated the brewery to Franklin and Brandon Streets. Skala is seen here with his wife and their daughter Anna.

In 1912, the Waupun Brewery changed its name to Waupun Brewing Company. It remained in the same location until it closed in 1916. The property was passed down to Anna Skala, who eventually sold it to the First Reformed Church of Waupun in 1956. The site is still known to many locals as Brewery Hill. Anna Skala is seen here standing second from the right. This photograph was donated to the Waupun Historical Society in 1932 by Esther McElroy.

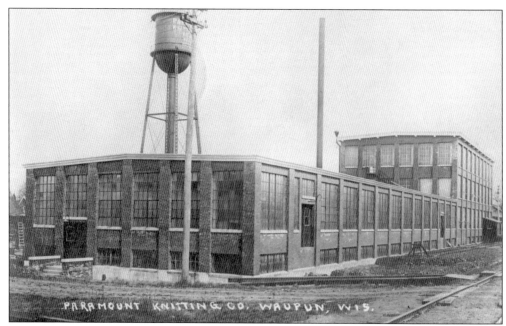

Paramount Knitting Co. was the parent company of the popular Bear Brand Hosiery. It had two mills, one in Waupun and the other in Beaver Dam. The mill in Waupun took advantage of prison labor, paying inmates a small wage to produce its products. After the practice of prison labor was discontinued, the company reached out to the local community for employees. Paramount was forced to close its doors after a labor strike in 1934.

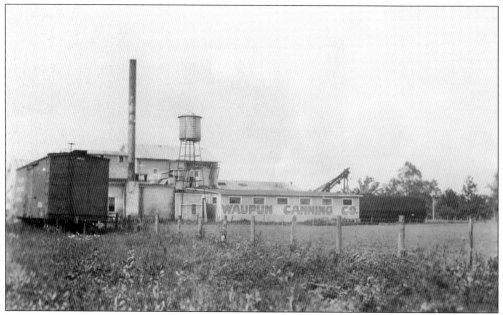

Owned by W.G. Glascoff, the Waupun Canning Company was a massive local industry, with two large plants in Waupun. The plants had a yearly output of about 300 carloads of peas, corn, beets, and pumpkins.

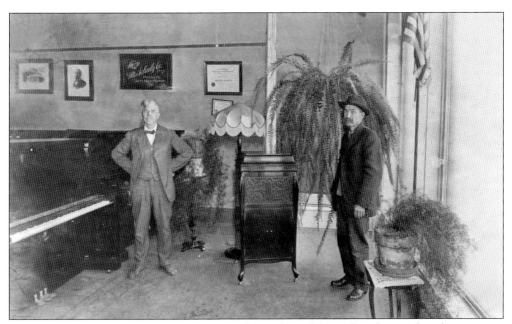

In the 1800s and up to the early 1900s, people conducted funerals either in their homes or in churches. They often depended on the local furniture store to supply wooden coffins. As funerals became more elaborate, furniture stores often branched out and supplied hearses and other funeral equipment. It eventually became very commonplace for furniture stores to also serve as funeral homes. Seen here is one of the old furniture stores, located on Main Street.

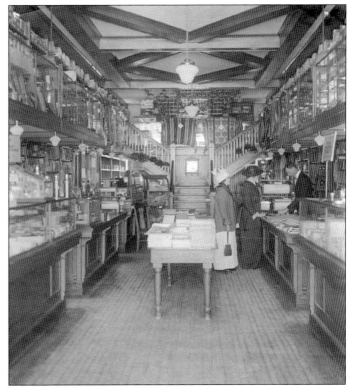

A local drugstore was located at 313 East Main Street for many years. It began as the Hunter Drug Store and then became the Patton Drug Store, which is seen in this photograph. This store's clerk, John A. Kastein, eventually became part owner of the drugstore.

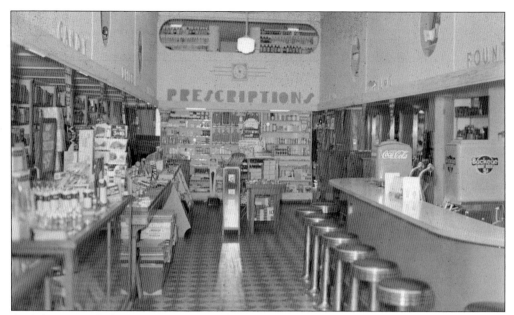

On February 1, 1925, Lester Damsteegt and John A. Kastein became partners in the newly named Kastein & Damsteegt Drug Store. In 1939, they entered into a major remodeling project, moving the stairway and relocating the prescriptions to the second floor. This created extra space for the new fountain shop and booths, which were increasingly popular additions to drugstores at the time.

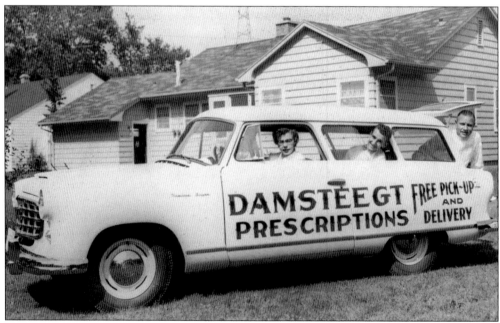

On February 1, 1948, exactly 23 years of partnership later, Lester Damsteegt bought out John Kastein to become the sole owner of Damsteegt Drug Store. In 1954, Damsteegt began offering free pickup and delivery, and, in 1956, he invested in a major remodel that made the store completely self-service and removed the fountain to bring the pharmacy back downstairs. Seen here from left to right are Marion and Bob Malnory and Lester Damsteegt.

Dr. William Marcellus Larrabee, a forward-thinking physician in the early 1900s, always believed schools should have a nurse. In his will, Dr. Larrabee left $18,000 to the City of Waupun to be invested until it could pay the salary of a nurse. In 1975, the will was contested because, as it was written, it would never have afforded a nurse. However, $100,000 had accrued over the years, and that money was put towards the first nurse's salary.

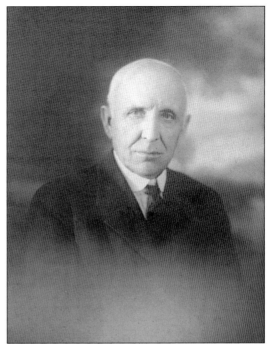

Dr. Rock Sleyster, seen here with his family, was born and raised in Waupun. He made a name for himself in 1939 when he became the first psychiatrist to be named president of the American Medical Association. He also held the post of medical director for the Milwaukee Sanitarium from 1919 until his death in 1942. His wife, Clara, established a memorial fund in his honor that awards scholarships to senior medical students with a demonstrated interest in psychology.

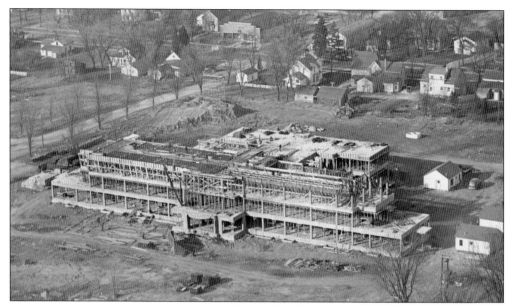

Waupun's first hospital study committee, dedicated to the construction of a Waupun hospital, was run by Edward W. Hooker and Ben Kastein from 1941 to 1943. Plans were delayed until 1947, however, due to lack of funds. The city eventually turned to the School Sisters of St. Francis of Milwaukee. With their contributions and donations from the people of Waupun, the 100-bed Waupun Memorial Hospital opened its doors on July 5, 1951. (Courtesy of Fletcher Studio.)

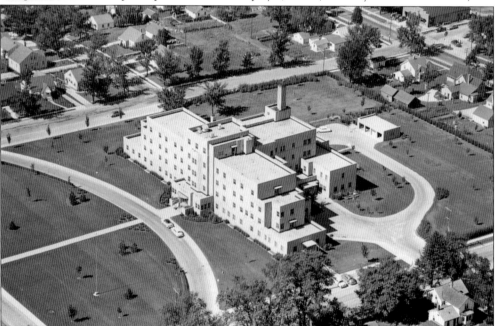

The very first hospital in Waupun was a small emergency and maternity hospital opened by Dr. Fay T. Clark and Dr. Kenneth Swartz. Located on the corner of Madison and Jefferson Streets, it closed in April 1950 following the death of Dr. Swartz. By 1951, Waupun Memorial Hospital, seen here, was open and being operated by the School Sisters of St. Francis of Milwaukee. The cost of the building and equipment was approximately $1.75 million.

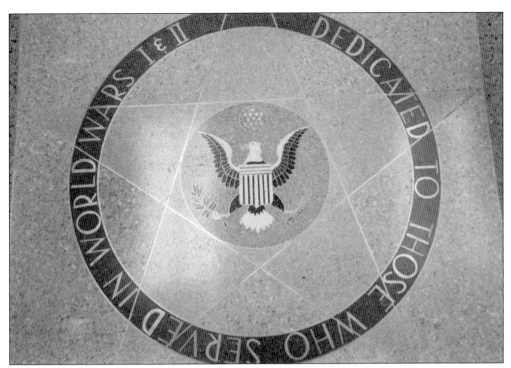

Waupun Memorial Hospital was built as a tribute to those who served in World Wars I and II. The star and eagle artwork pictured here was displayed in the hospital's lobby floor for many years until it was covered by carpet. When the carpet was taken up, the commemorative piece was again displayed for all to see. It remained until a major renovation made it necessary to remove it from the floor for good.

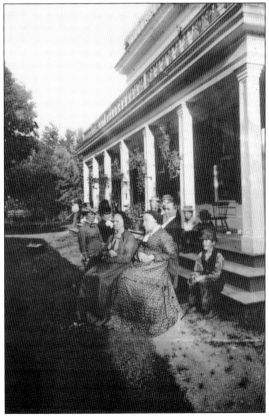

After moving his family to Waupun in 1847, Edwin Hillyer became one of the city's most influential men in its early years. He was instrumental in bringing the railroad to Waupun, served in the state legislature, and was a captain in the Civil War. Hillyer (center, with beard) is seen here surrounded by family around 1873. His wife, Angeline Coe Hillyer, is at front right. (Courtesy of the Wisconsin Historical Society.)

In 1881, Ernest Doering opened Doering Jewelry Co. in Waterloo, Wisconsin. The firm eventually moved its headquarters to Waupun. Olga Doering apprenticed under her father and then took over the Waupun store at the age of 16. Olga married Myron Gysbers and eventually changed the store's name to Gysbers Jewelry. The Gysberses' son E. John Gysbers took over the store in the mid-1960s, running it until his own daughter Kate (Gysbers) Bresser purchased it from him in 1992. A young Olga Gysbers is seen here standing in the background in Gysbers Jewelry.

In the early 1900s, Waupun had a multitude of clothing shops catering to men, women, and children. This photograph shows the interior of one of these shops, on Main Street.

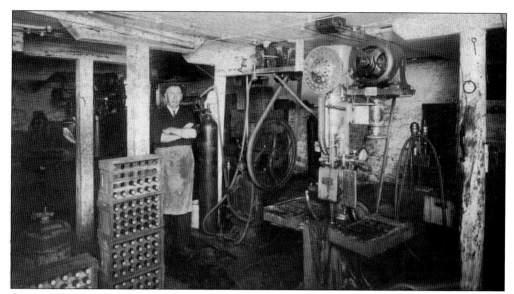

Otto Amthor founded Waupun Bottling Works around 1909. It was located at 25 North Drummond Street and offered sodas, candies, cigars, and popular beers. In 1912, Amthor offered the first carbonated soda made in Waupun. It was called Iron Brew and tasted of root beer. He also sold beer made by the Jung Brewing Company of Milwaukee. In 1926, Walter Paskey sold his grocery store on Main Street to join Amthor as a partner. They named their joint venture Star and Crescent Beverages. Amthor died in 1941, leaving Paskey as the sole owner. Paskey eventually passed the business on to his two sons Carl and Don Paskey.

An unidentified woman stands in front of the building that would become Andy's Tap, a popular bar on Main Street in the 1940s and 1950s. (Courtesy of Fletcher Studio.)

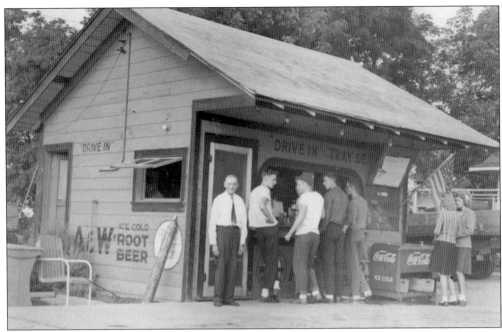

Carl Johnson introduced two novel businesses to Waupun. The first was the cultivation of ginseng in 1908. This crop was raised along Beaver Dam Street. After the 1930s, ginseng was no longer profitable, so Johnson changed gears and opened the first A&W chain in Waupun. Johnson is seen here on the far left in front of his A&W, which stood on Main Street where the Kwik Trip is today.

Martin Olson, born on April 10, 1901, is seen here standing in front of his restaurant, Olson Bros. Cabaret, located at 435 East Main Street. During a building renovation, the location of the door was moved to the front for many years; it just recently moved back to its original location. This building has remained a restaurant through the years and is currently the Chit Chat Café.

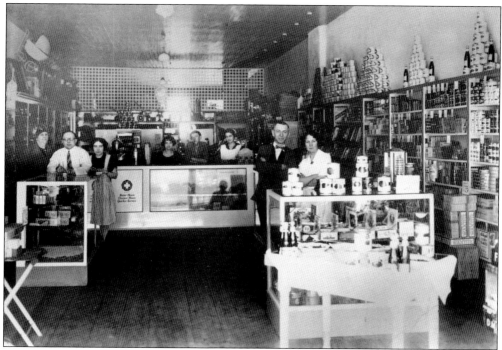

The Bernhard & Houdek store was an all-purpose store in the 1920s. This 1926 photograph shows employees (from left to right) Mrs. Greibel, Frank Houdek, Cecelia Luck (Verhulst), Minnie Vaude Zande, Ruben Kanzenbach, Ella Knoll, Al Bernhard, and an unidentified female employee. (Courtesy of Jim Laird.)

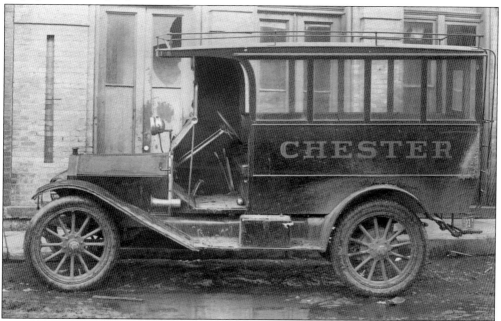

The small town of Chester was an important neighbor to the east of Waupun. Both had separate railroads, and this bus allowed the people of each town to travel between the towns, taking advantage of both railways in the early-to-mid 1900s.

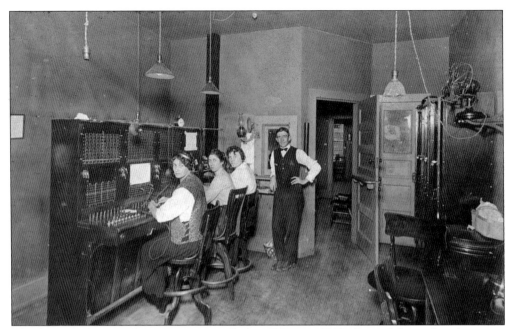

The first telephone in Waupun was installed in February 1880. One of the earliest lines was connected to the town of Chester by a grounded line. A small exchange was established, and Dr. T. M. Welch was the first night operator. By 1931, the service was located at 112 South Madison Street. Seen here from left to right in 1915 are Lydia Weckworth, Edna Browne, Anah Keech, and Andrew Halkier. Weckworth was a notable night operator for over 25 years.

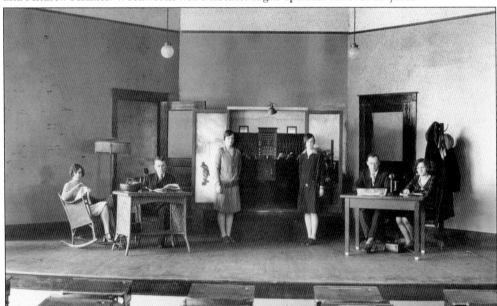

In 1900, Waupun had a population of 3,185 and had 32 telephones. By 1910, the subscriber ratio jumped to about one in ten residents, with 327 subscribers. In 1927, with a population of about 5,000, over 1,200 subscribers were being served. In 1961, Waupun switched to dial phones and all new phone numbers. This photograph shows a demonstration of the new phone service offered in 1928, put on at the 1913 high school.

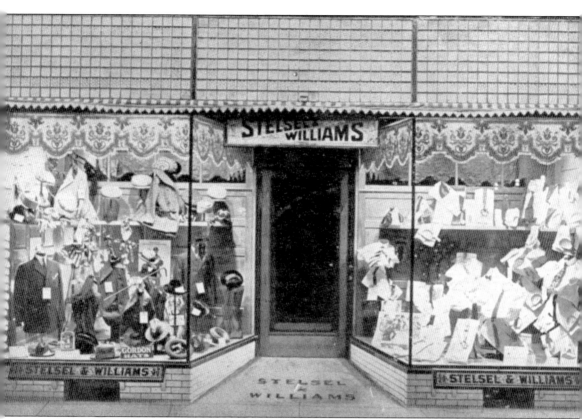

Stelsel & Williams, located on Main Street, was a leading men's clothier and furnisher for Waupun. The store purchased an advertisement in the *Waupun Hi Flier* yearbook of 1917. This image came from a Stanley Johnson postcard dated 1913.

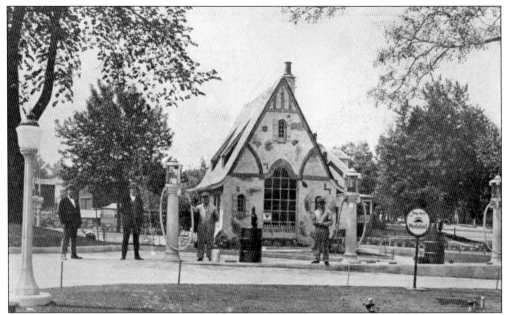

The Powder Puff gas station, featured in the June 1927 issue of *Master Builder*, was located on Watertown and Fond du Lac Streets. The station was built to appeal to affluent female motorists during the women's movement of the early 1900s. It was nicknamed Powder Puff in reference to its large, upscale powder room, which it furnished with wicker chairs, a settee, and a reading table.

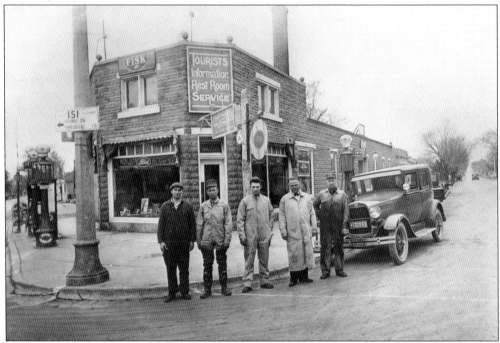

Known as the Ford Garage, this shop was located on Main and Fond du Lac Streets. It offered car sales and service. Pete's Repair was a longtime resident of this shop, until the growth of the business required it to move across the street. (Courtesy of Fletcher Studio.)

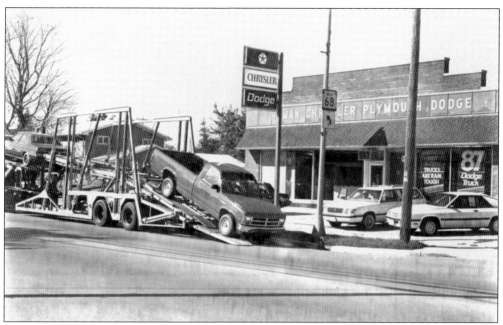

Ed Homan opened his first used car dealership in 1974. At first, it was run by a thin staff of just Homan, his wife, Flora, and one service technician. Business flourished and Homan soon brought two of his sons, Jeff and Steve Homan, on board. By 1986, a third son, Mark, joined the team. This storefront is the original used car building. (Courtesy of Ed Homan.)

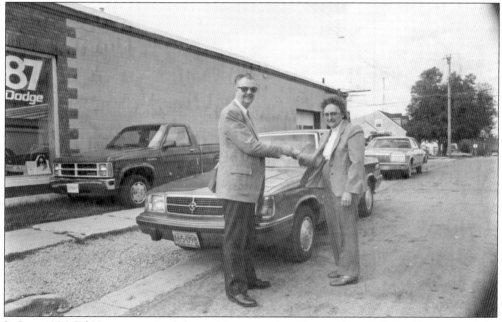

In June 1986, Ed Homan received the exciting news that Homan Auto Sales had been awarded a new Chrysler franchise, which included the Plymouth and Dodge brands as well. This photograph captures Homan's first new vehicle being delivered to its proud owner, Rita Smith. Homan's is still family-owned today and has three locations, two in Waupun and one in Ripon. (Courtesy of Ed Homan.)

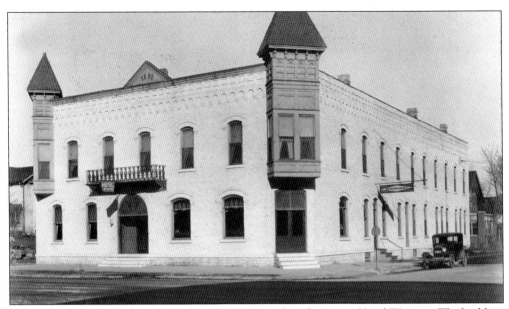

The National Hotel, built on Main Street in 1890, was later known as Hotel Waupun. The building was eventually razed to make room for a parking lot for the National Bank of Waupun. In 1925, John D. Westra moved his real estate and insurance sales business, the Westra Agency, into the building, which is seen here in 1931. Changes came in 1948 when Watson Sterk, Westra's son-in-law, became a partner, and the office was relocated to 520 East Main Street.

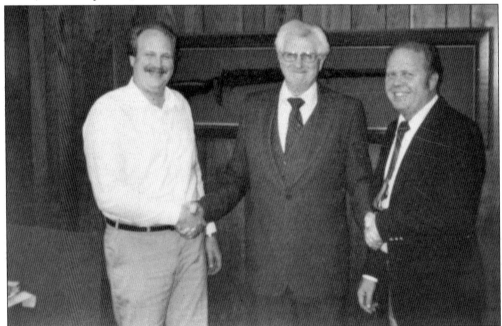

Watson Sterk purchased the company in 1956 and ran it for many years. By 1976, it had officially become the Sterk Insurance Agency. This 1983 photograph captures the change of ownership from Watson Sterk (center) to his son Joel Sterk (left) and Glen Westra (right). Now known as SAI, it continues to be a family-oriented company with its new partners: Joel Sterk, John Theune, and Peter Hansen.

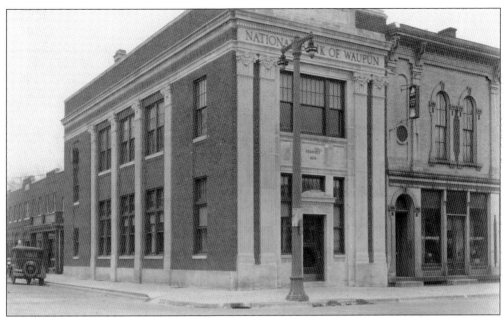

In 1876, George Hess constructed a two-story bank building on the corner of South Mill and Main Streets. He then sold the bank to the First National Bank of Waupun, which received authorization to open on September 1, 1885. In 1904, First National made an addition to the building and installed an electronic burglar alarm. The bank's charter expired in 1905 and it reorganized under the new name National Bank of Waupun.

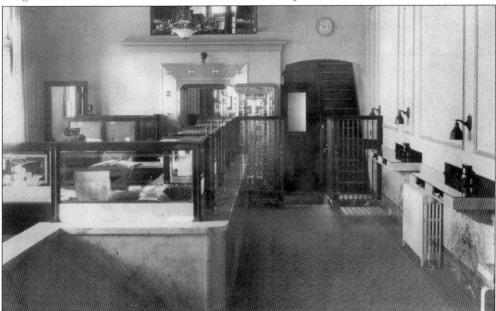

Under the new charter of 1905, stock in the National Bank of Waupun was sold to local residents. A new building was constructed at 210 East Main Street in 1957 to allow for a more spacious lobby and new equipment. By 1975, the building was remodeled to include three drive-up lanes. The bank has since expanded to locations in Brandon, Fairwater, and Rosendale. This photograph shows the interior of the old bank building.

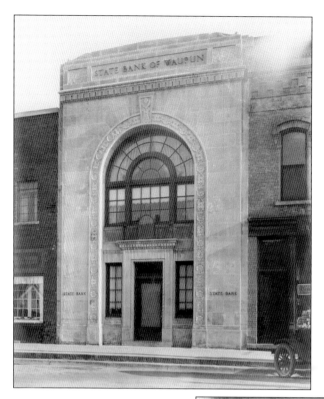

The State Bank of Waupun was organized on October 1, 1903, by seven local businessmen. The original building still stands at 317 East Main Street. In the early years, the bank only had about $25,000 in capital, so the president and cashier only received $600 for their yearly salary. By the time this photograph was taken, in 1929, the original building had been completely remodeled. (Courtesy of Jim Laird.)

This photograph shows the newly remodeled interior of the State Bank of Waupun in 1929, right before the onslaught of the Great Depression. Fortunately, the bank managed to keep its doors open during the Depression. Later, in 1966, it relocated to 37 North Madison Street. In 1984, the bank merged with the First Interstate Corporation and became the First Interstate Bank of Wisconsin. It is now owned by Wells Fargo. (Courtesy of Jim Laird.)

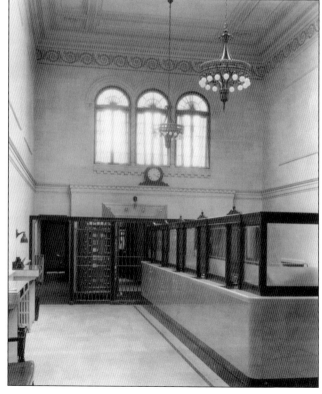

Five

SHALER'S CITY OF BUSINESS AND SCULPTURE

"Tomorrow is Today's Dreams." These words were spoken by iconic Waupun businessman, inventor, sculptor, author, and philanthropist Clarence Addison Shaler, who was born on May 29, 1860, on a homestead farm in Green Lake County. As a young farm boy, he showed his innovative strengths by inventing a cat-powered treadmill that would churn butter, as well as the first ride-behind sulky plow, to help alleviate the pain he had from a broken leg that was set improperly. (Courtesy of Fletcher Studio.)

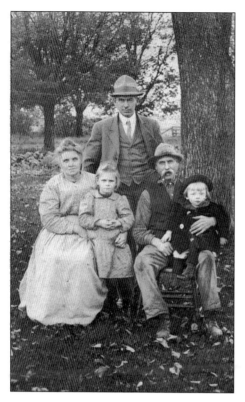

Clarence Addison Shaler attended Ripon College for three years until the death of his father, in 1881, forced him to leave college and run the family farm. Due to his poor health, farming did not suit him, and, after several years, he left to invest in a flaxseed mill in Waupun. The mill soon failed, which gave Shaler and the other investors the opportunity to use the empty building for the production of his new concept for umbrellas. Shaler became a millionaire with inventions such as the Monarch Umbrella, Vulcanizer hot patches, and Rislone. The Shaler Company also manufactured golf clubs and grills. In the mid-1920s, *Who's Who in America* listed Shaler as an outstanding leader in his field. He did this all with his wife, Blanche Bancroft Shaler, and his only child, Marian Shaler, at his side. It was not until Shaler was in his 70s that he started working on his passion of sculpting. He is seen at left with family members and below at the Rock River Country Club.

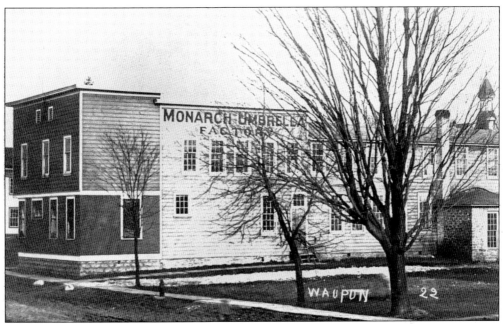

In the days before synthetic materials, umbrellas were made of cotton, and the wet cotton would eventually rot. Clarence Shaler conceptualized an umbrella that allowed people to replace the worn-out cotton top, saving them from having to purchase an entire new umbrella. The revolutionary idea turned Shaler's Monarch Umbrella factory into a success story.

Shaler was a true believer in advertising and was known to dedicate a higher proportion of funds towards advertising than most companies of his era. This is one of his earliest and best-remembered advertisements, for the Shaler Electro-Pad in 1910. (Courtesy of National Rivet.)

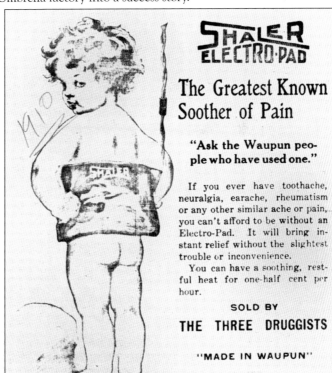

SHALER ELECTRO-PAD

The Greatest Known Soother of Pain

"Ask the Waupun people who have used one."

If you ever have toothache, neuralgia, earache, rheumatism or any other similar ache or pain, you can't afford to be without an Electro-Pad. It will bring instant relief without the slightest trouble or inconvenience.

You can have a soothing, restful heat for one-half cent per hour.

SOLD BY

THE THREE DRUGGISTS

"MADE IN WAUPUN"

C. A. SHALER CO.

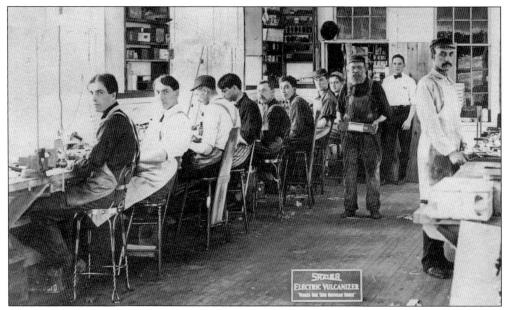

Clarence Shaler was the second person in the state of Wisconsin to purchase an automobile. Due to numerous problems with flat tires and the lack of repair options during the first years of the automobile, Shaler invented the first vulcanized hot patch in 1905. It was the first practical hot patch that could easily fix the tubing of flat tires. Shaler associated with F.E. Jones and Walter Graham to form the C.A. Shaler Company.

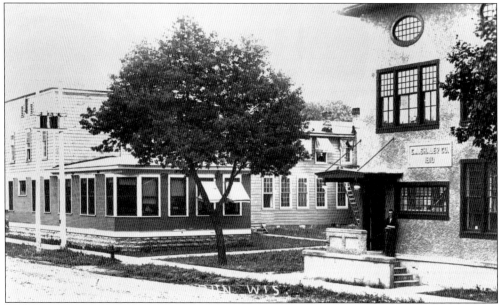

The first Vulcanizers were electric, but by 1910, Shaler purchased the patent and manufacturing rights for the portable Stitch-in-Time Vulcanizer. He constructed a new building to allow for the expansion of this portion of his company and soon began manufacturing Shaler Roadlighters (headlights) and, in 1928, golf clubs. In the 1930s, National Rivet began to purchase Shaler Company stock; by the mid-1950s, it had controlling interest. In 1974, National Rivet became sole owners of the company.

Elbert Hubbard and his son Elbert II demonstrate the first Shaler Electric Vulcanizer in 1908. Hubbard Sr. was an author and publisher who was best known for founding the Roycroft artisan community in New York. Hubbard thought so highly of the Vulcanizer that he made considerable comments about the product in his writings. Sadly, Hubbard and his second wife, Alice Moore Hubbard, lost their lives in the sinking of the RMS *Lusitania* in 1915.

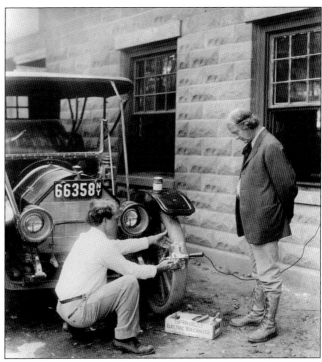

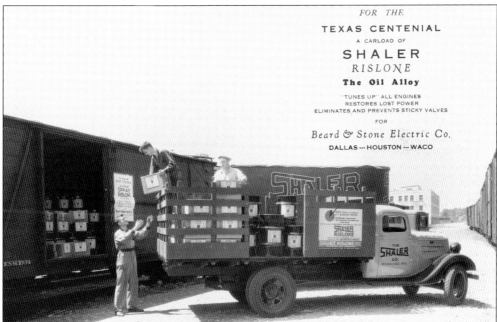

Invented in 1921 by the Shaler Company, Rislone was one of the original automotive chemical additives. In the late 1930s, Clarence Shaler developed a training system for mechanics called the Shaler Rislone Tune-Up System, which enhanced a regular oil change with the addition of Rislone and Karbout, a carburetor cleaner. The additive was known for improving performance and was instrumental in coining the term "tune-up." The locations that followed the system were designated as "authorized tune-up service stations."

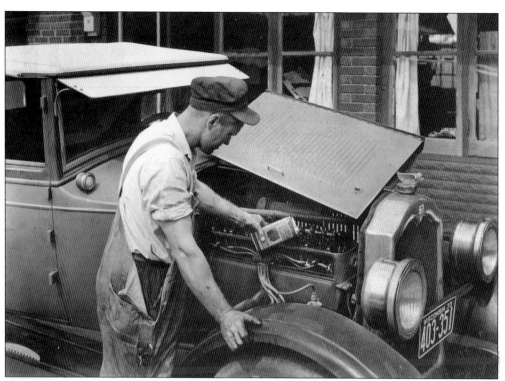

Harry Harmsen is seen here pouring Shaler's Rislone into a vehicle at the Ford Garage on Division Street.

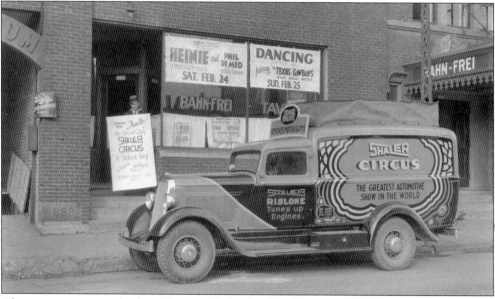

Always an innovative thinker, Clarence Shaler developed an advertising and marketing scheme that brought his very own automotive circus to entertain current and potential clientele. While wowing his audience with entertainment, he very cleverly advertised and sold his products, like Rislone. The Shaler Circus traveled to many different towns, playing at venues such as the Pabst Theatre in Milwaukee.

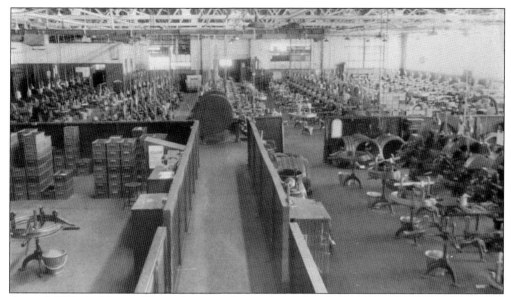

Around 1929, the National Rivet Company first set up its rivet operation in the Shaler plant. Over the next four decades, National Rivet began to purchase Shaler Company stock, and, by 1974, it had acquired 100 percent of the Shaler stock. Today, National Rivet is still a family owned and operated international business. Seen here is one of National Rivet's header rooms, where coils of many types of metals are fed through automatic riveters and boxed.

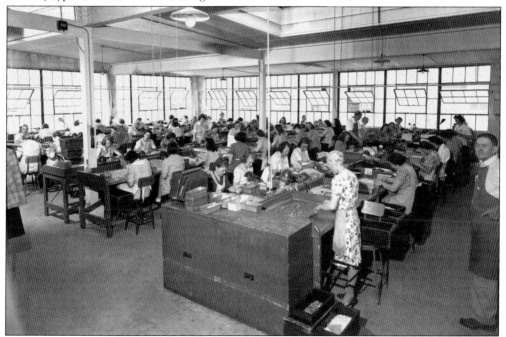

National Rivet played its own part in the World War II war effort as a supplier of aircraft rivets to the military. Rivet, known for its applications where close tolerances are imperative, operated under the name Mid-State Manufacturing Company during the war. This was to ease relations with other manufacturers who would have otherwise thought of them as competition. Here, employees work on quality inspections of the rivets in 1944.

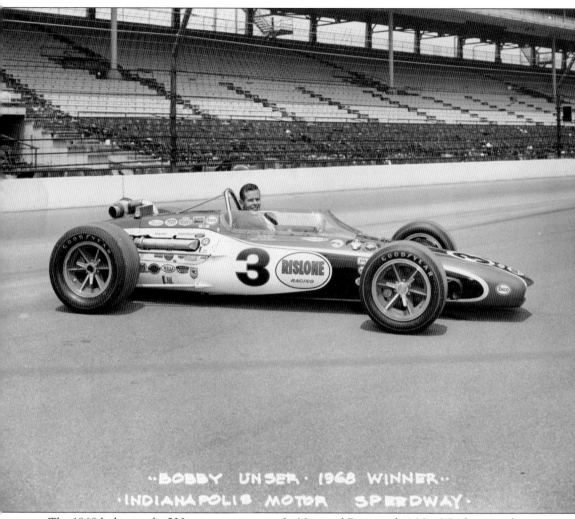

..BOBBY UNSER · 1968 WINNER..
·INDIANAPOLIS MOTOR SPEEDWAY·

The 1968 Indianapolis 500 was an epic event for National Rivet and its No. 3 Rislone car driver, Bobby Unser. National Rivet has long been known for its support and participation in automobile racing, but this race topped them all. Unser led most of the first half of the race, while Mario Andretti dropped out due to a bad piston. Unser's car was stuck in high gear and had to stop for one last pit stop. With only 19 laps to go, Joe Leonard passed Unser before Unser could get up to racing speed. The green flag was flown on lap 191, and, at that instant, Leonard's engine failed. Bobby Unser zipped past Joe Leonard, stunning the crowd and taking back the lead for his first win at the Indy 500. National Rivet went on to sponsor more racecars, but none who won the Indianapolis 500.

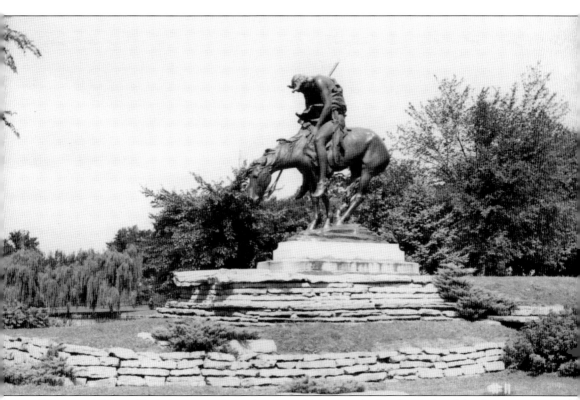

Clarence Addison Shaler's passion for sculpture and his empathy for the plight of the American Indian led him to commission a bronze replica of the James Earle Fraser plaster sculpture *End of the Trail*. Shaler struck up a friendship with the artist after meeting Fraser at the 1915 Panama-Pacific World's Fair in San Francisco. Fraser, an award-winning sculptor, had originally intended for *End of the Trail* to be made in bronze, but when he found himself short of funds, he decided to make the statue from plaster and paint it to look like bronze. This bronze replica was presented to the City of Waupun by Clarence Addison Shaler on June 23, 1929. It now sits in Shaler Park, where Shaler had selected a spot between the dam at the Rock River and the Forest Mound Cemetery.

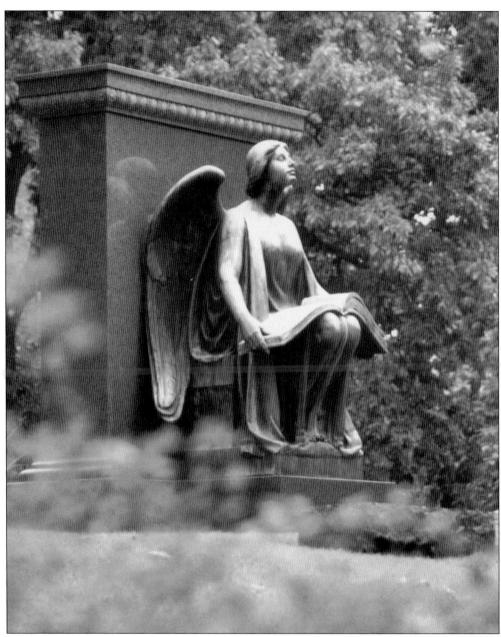

While on a trip to Chicago for treatment of ill health, Clarence Addison Shaler came upon the studio of Lorado Taft, who would become known as one of America's foremost sculptors. The two bonded over their love of sculpture and became lifelong friends. When Shaler's beloved wife, Blanche Bancroft Shaler, passed away, Shaler turned to Taft to create this heroic-size statue, *The Recording Angel*, as a memorial to her. He was married to Blanche for 26 years and they had one daughter, Marian Shaler. The piece shows extreme detail and depicts a serene angel who has just completed reading the record of a good life. *The Recording Angel* was presented as a gift from Shaler to the City of Waupun in 1923 and is located in the central part of the Forest Mound Cemetery, near Shaler's gravesite. The sculpture was listed in the National Register of Historic Places in 1974. (Courtesy of Scheer's Photography.)

On February 8, 1878, Clarence Addison Shaler's twin sister, Clara A. Shaler, died at the young age of 18. This tragic memory later inspired Shaler's sculpture *Morning of Life*, which he created in 1936 in her memory. At the dedication of the statue, Shaler said, "Death is more beautiful than life, for the dead are ever young." The statue is placed on Clara's grave in Mackford Union Cemetery, 12 miles northwest of Waupun. (Courtesy of Scheer's Photography.)

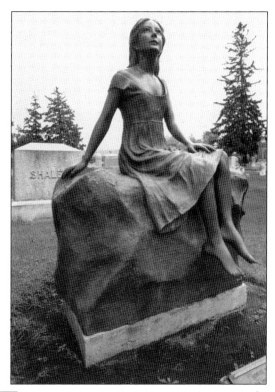

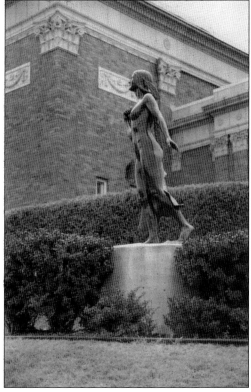

Dawn of Day, the translation of the Native American word "waubun," was Clarence Addison Shaler's first bronze statue. He dedicated it to the City of Waupun in 1931, saying: "Like this Indian maiden who is casting off the old garments . . . who will ever look forward to the dawn of a new day . . . I hope the people of Waupun a day of greater prosperity and happiness." The sculpture is outside the city hall in Waupun. (Courtesy of Scheer's Photography.)

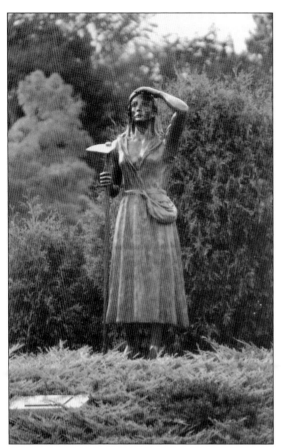

Who Sows Believes in God was created by Clarence Addison Shaler in 1939. The statue spent 30 years in a basement after a University of Wisconsin professor labeled it "inferior art." After 15 more years in an isolated spot, Waupun historians recognized the value of the piece and petitioned to bring it to Waupun. The statue was dedicated in August 1995 and is located at the corner of Brown and Beaver Dam Streets. (Courtesy of Scheer's Photography.)

Clarence Addison Shaler, one of the founders of the Rock River Country Club, created the sculpture below of a doe and her fawn as a tribute to the pastoral scenes one can find there. Shaler created the piece in 1932 at his Pasadena studio and originally called it *Group of Deer*. It is still located at the Rock River Country Club today. (Courtesy of Scheer's Photography.)

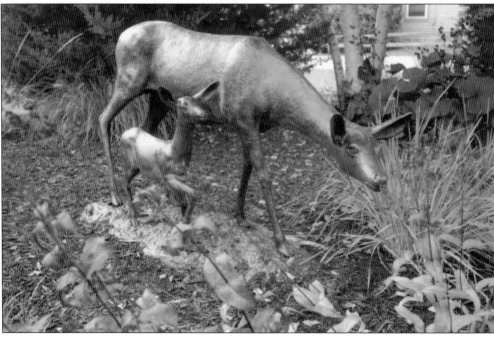

As a former Ripon College student, Clarence Addison Shaler paid homage to his former school by dedicating his sculpture *Abraham Lincoln*, also known as *Lincoln the Dreamer*, to the college in 1939. The statue shows a young Lincoln in the "morning" of his life. This statue still stands at Ripon College today.

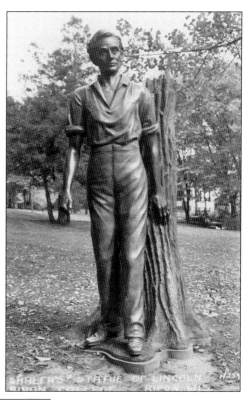

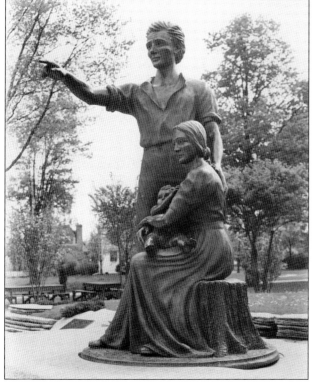

Pioneers was sculpted by Clarence Addison Shaler in memory of his mother's steadfast dedication to her family and the optimism that helped the early pioneers forge ahead. The piece was completed in time for the 100th birthday celebration of Waupun and was given to the City of Waupun just 14 months before Shaler died. It has been located in Wilcox Park since 1940. (Courtesy of Fletcher Studio.)

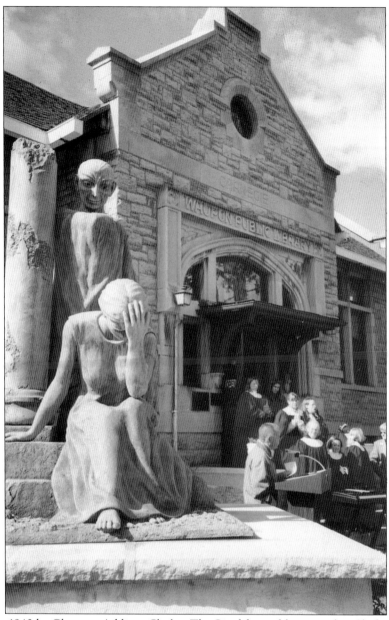

Created in 1940 by Clarence Addison Shaler, *The Citadel* is unlike any other Shaler sculpture. Considered one of his masterpieces, it shows a devil-like creature hovering over a desperate woman with her head in her hand. Family members say the dark nature of the piece may depict Shaler's feelings towards the horrific actions of Nazi Germany during World War II. It is also known that Shaler suffered from poor health stemming from a lame leg that was set incorrectly after he broke it as a child. The many years of pain medications ruined his digestive system and caused him much difficulty throughout his adult years. The sculpture was on display at the University of Southern California from 1942 until 1994, when Stuart Hanisch, a grandson of Shaler's, brought it to Waupun. This photograph was taken at the dedication ceremony in front of the Waupun Heritage Museum, where the statue remains today. *The Citadel* was one of the last sculptures Shaler created before his death in 1941.

Six

ORGANIZATIONS OF COMMUNITY AND FAITH

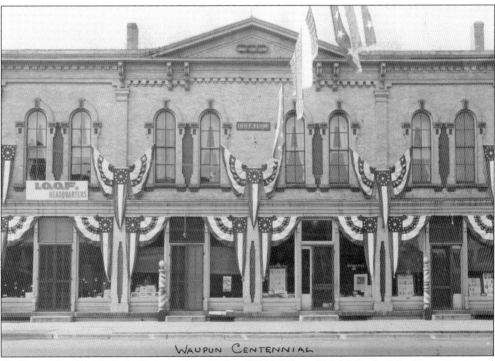

On December 25, 1848, the Independent Order of Odd Fellows Telulab Lodge No. 33 was instituted in Waupun. James McElroy is listed as the first noble grande. In 1852, the organization built its first building, on Main Street, for $600. By 1871, it had constructed a new brick building, which still stands just east of city hall. This centennial photograph shows the Odd Fellows' linked "OOO" insignia on the top of the building.

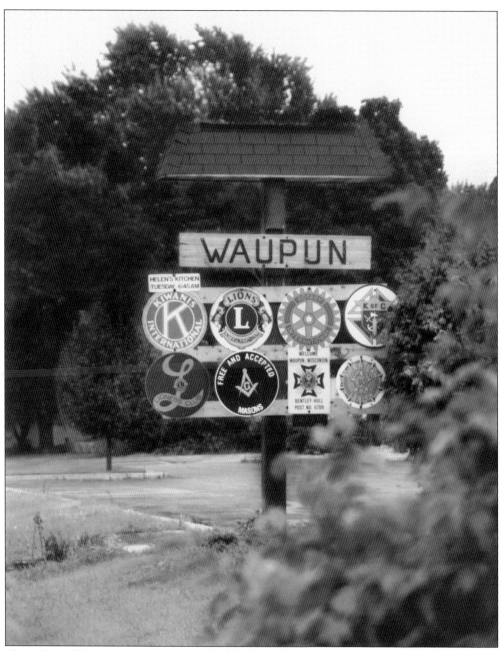

Throughout Waupun's history, organized clubs have been an important part of the leadership, cohesiveness, and betterment of Waupun society. All of the following clubs have long histories of contributing greatly to the community of Waupun through charitable projects, community service, and fundraising initiatives, often working together on projects to make an even greater impact. The Kiwanis Club was first organized in 1929, with 35 charter members. The Lions Club was chartered in 1963, with 22 members. The Lioness Club was chartered in 1976, with 19 members. The Rotary Club was chartered by a group of men in 1922, and membership was opened to women in 1988. The Knights of Columbus was instituted as a fraternal organization of Catholic men in 1960. (Courtesy of Scheer's Photography.)

On August 12, 1853, the first Waupun Masonic Lodge No. 48 was established at a meeting in the Odd Fellows lodge. Top businessmen and leaders of Waupun, including Hans Christian Heg, were the first members. In 1900, the lodge allowed for the installation of the first electric lights, and, in 1919, after World War I, members authorized $6,000 for the purchase of the Mathilda Keuchenberg house, seen here.

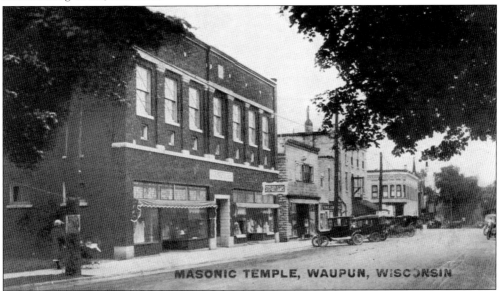

The Masonic lodge decided to add onto the front of the Keuchenberg house, located next to the Carnegie Museum on South Madison Street. They were able to keep a large portion of the house intact. By the time the building was dedicated on December 21, 1922, the total cost for renovations was $31,000. The lodge has always been devoted to the causes of welfare, charity, and relief. The social aspect of the organization is also emphasized.

This photograph was taken in 1960 at a variety show put on by the Waupun Kiwanis Club. All of these men were prominent businessmen and members of the noon Kiwanis Club. They are, from left to right, Carrol Godshall, Walter Dalton, Milton Schmuhl, Robert Rompre, Robert Elvers, William Blow, Charles Goebel, Dr. James Hendrick, Paul Wiese, and John Kirkpatrick.

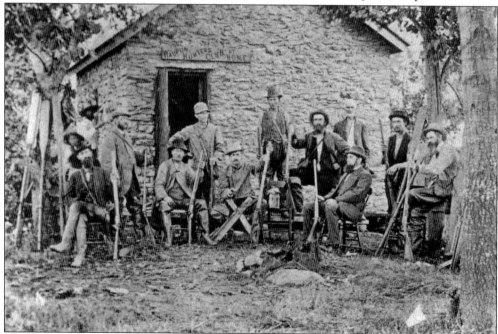

The Waupun Hunter's Club was a popular social outlet for farmers and businessmen in the late 1800s. The clubhouse was built by Charles Rank around 1873 at a location in Horicon Marsh called Stony Island, about four miles southeast of Waupun.

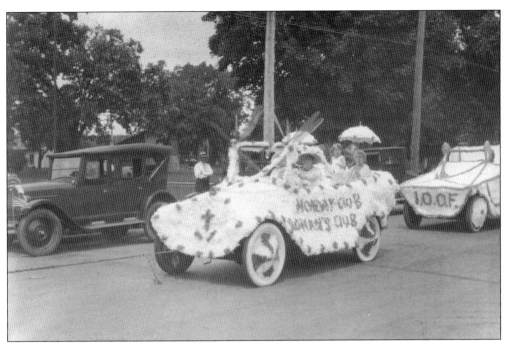

On October 27, 1898, a group of 15 intellectual women seeking to better themselves started the Waupun Monday Club. During a time when few women had the means to a proper education, the club's main objective was self-improvement by studying the arts, literature, history, and world affairs. After 70 years, the club disbanded in 1968. The Monday Club float is seen here participating in the 1928 homecoming parade.

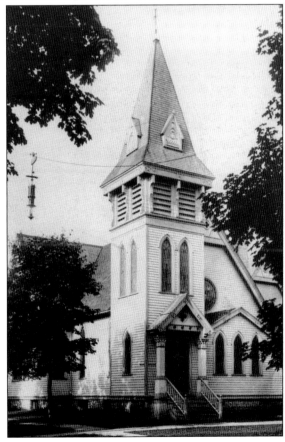

Rev. Silas Miller, a traveling preacher, was the first person to preach a sermon in Waupun. In the autumn of 1844, Reverend Miller organized the Methodist Episcopal church with six members of his own family. It was the first organized church in Waupun; meetings were held in the homes of congregation members until they were able to build a small frame church, which was also used as the town schoolhouse.

The first official service of the Waupun Holy Trinity Episcopal Church was recorded on October 6, 1862. By 1867, the mission was formally organized, and many of the first local families are listed as organizing members of the church. The cornerstone of the church is dated September 11, 1871, and it was admitted into the Fond du Lac Diocese in 1878. It is the oldest church building still being used today in Waupun.

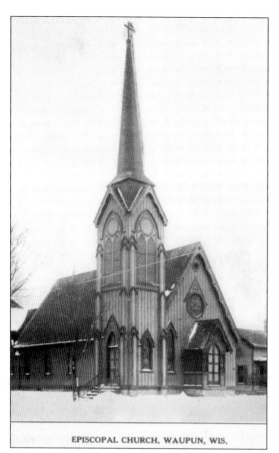

EPISCOPAL CHURCH, WAUPUN, WIS.

In the 1850s, Waupun welcomed many new Irish settlers who fled their home country during the potato famine. Since many Irish activities revolved around the Catholic Church, the pastor of Fox Lake Catholic Church erected a wooden church on the corner of Main and Division Streets, naming it St. Joseph. By 1866, the parish received its very own pastor, Fr. George Willard. In 1906, the church raised enough funds to build the brick church pictured here.

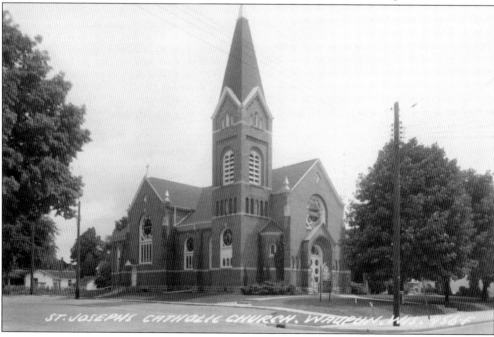

In the early development of Waupun, there were many organized churches, and the small village could not support the high number. To alleviate the problem, in 1897, three Baptist churches combined to create the Union Church. By 1900, the new congregation chose to build its church on Baptist Hill, where the city hall is today. Only 16 short years later, the Union Church was destroyed by a fire.

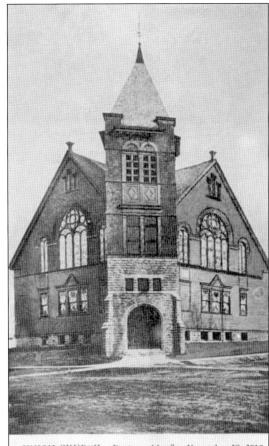

UNION CHURCH. Destroyed by fire November 19, 1916.

The Union Church was unable to afford a new structure after the fire and made the decision to join First Congregational Church, thus forming Union Congregational Church. The services were held at First Congregational Church (below). This church was built in 1850 on Madison Street. In 1958, the old church building was sold to the Waupun Savings and Loan Association. The current church is located at 125 Beaver Dam Street.

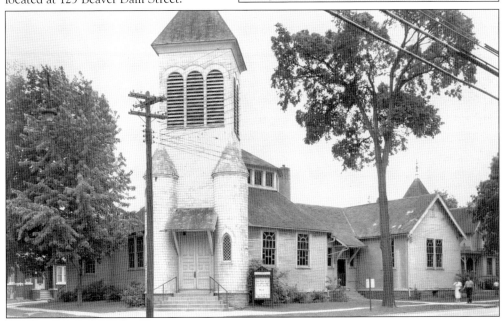

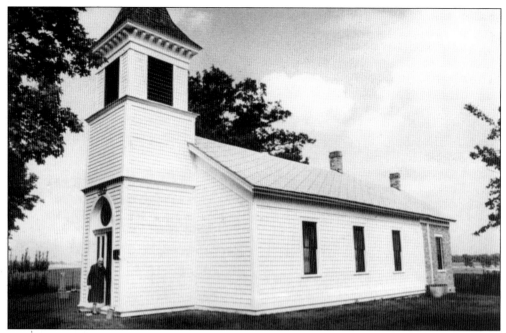

The Old Norwegian Church, built in 1855, is located two miles east of Waupun on Church and Oak Center Roads. In the mid-1800s, the church was the center of an early community of Norwegian immigrants. Even though the little church never had electricity or plumbing, circuit-riding pastors conducted weekly services there until 1920. A caretaker of the church for many years, Mrs. Theo Helgeson, is standing in the doorway.

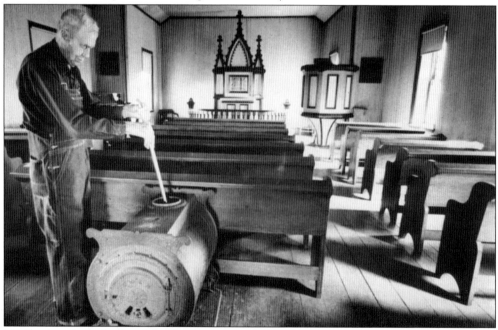

To this day, the little church holds an annual service that the public is invited to attend. Here, Theo Helgeson, a caretaker of the church, attends to the stove. Both photographs on this page were taken by the late Edgar G. Mueller of Mayville.

In 1882, Rev. John Burkhard conducted the first service at the Waupun Immanuel Lutheran Church. The services had been held in the German schoolhouse on the corner of State and Taylor Streets until 1881. By 1910, the members had built a new church on Main Street, and, within a year, the congregation held its first English service. Separate English and German services were held until March 1, 1953, when German services were discontinued.

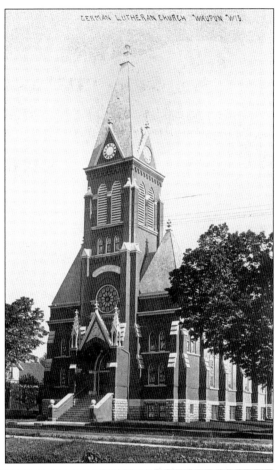

Emmanuel Reformed Church was organized in 1941, when 34 families broke from the First Reformed Church. From 1942 until 1947, services were held in the Lincoln School gymnasium and led by the first pastor, Rev. Gerrit Menning. The congregation's plans to build its future church were postponed due to restrictions in effect during World War II. The new church (pictured), located on the corner of West Brown and Hillyer Streets, was completed in 1947.

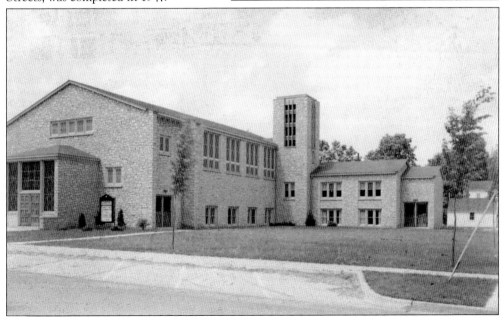

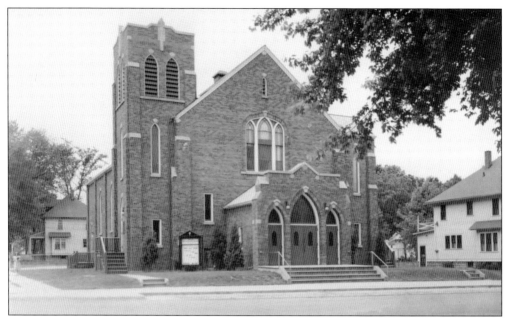

The First Christian Reformed Church of Waupun is considered the "daughter" of the Alto Christian Reformed Church. In the 1920s, the trek from Waupun to Alto was difficult, so a closer congregation was formed. In June 1922, the membership built their first church. Dutch services were discontinued at the church in 1945. In the 1960s, the church sponsored the radio broadcast *The Bread of Life.*

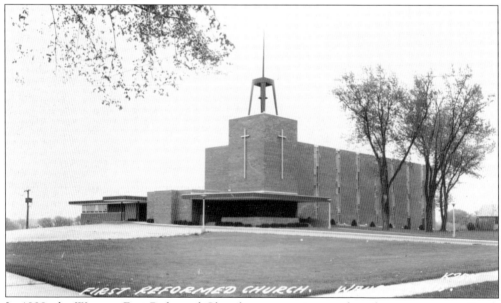

In 1888, the Waupun First Reformed Church congregation purchased a parsonage on South Drummond and East Brown Streets. A simple building was erected in 1889, which served the congregation for 35 years. In 1937, a group of 34 families left to start Emmanuel Reformed Church, and, in 1955, a group of 70 families left to establish Trinity Reformed Church. In 1956, the First Reformed Church purchased the Waupun Brewing Company property on Franklin Street for the site of its new church.

Seven

MAIN STREET VIEWS AND BEYOND

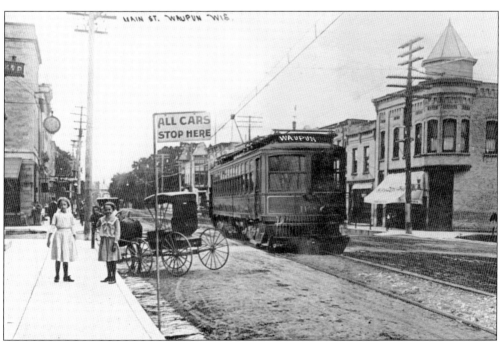

This comedic postcard, most likely created by Alfred Stanley Johnson around 1910, shows a rail car running down Main Street. A train has never traveled down Main Street; however, both Main Street and the train were integral parts of the city's development and growth. This photograph was taken from the intersection of Madison and Main Streets looking west.

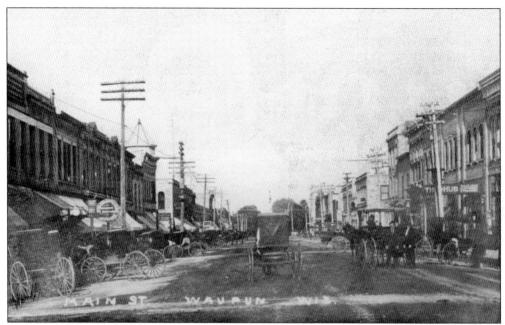

In the early years, before cars, it was common to see Main Street filled with horses and buggies. Almost all activity and business was centralized around Main Street. This photograph looks east on Main Street towards the intersection with Madison Street. There are clothing stores on either side of the street. The Hub, on the south (right) side of the street, was a popular men's clothing store for many years.

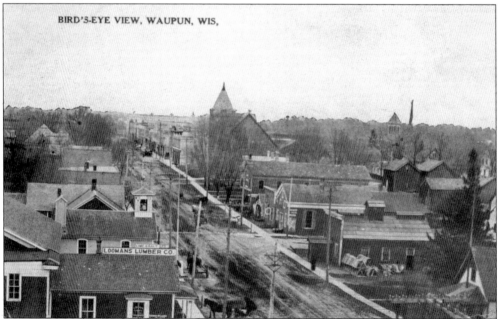

BIRD'S-EYE VIEW, WAUPUN, WIS,

This postcard, dated 1915, shows a bird's-eye view of early Main Street looking east. Loomans Lumber Co., in the lower left, stood approximately where Warner Harmsen Furniture is today. The old Union Church roof tower can also be seen, in the middle of the photograph. That church was destroyed by a fire, and the site eventually became home to Waupun City Hall in 1928.

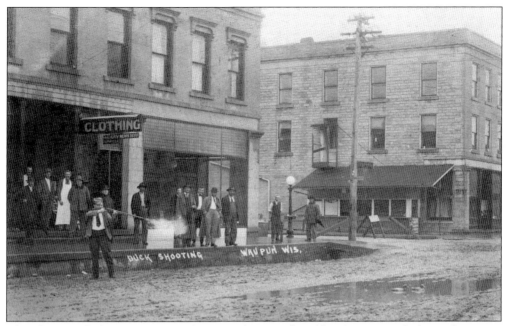

This photograph shows sportsmen of Waupun having a bit of fun shooting at ducks on the corner section of Main and Madison Streets, where Van's Corner Drug stood for many years. The building is currently occupied by Sully's Sporting Goods. Also visible behind the men are a clothing store and the city news depot.

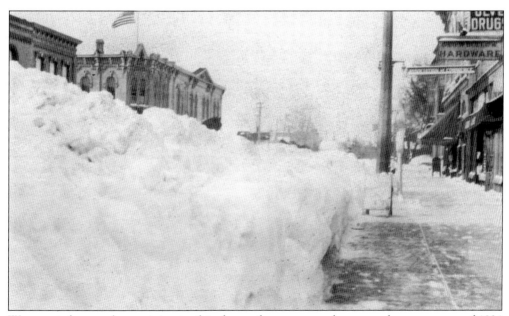

Waupun is known for receiving its fair share of snowstorms; however, the snowstorm of 1924 was so incredible that one could barely see across Main Street. This is a view of the Fond du Lac County side of the street looking west. (Courtesy of Jim Laird.)

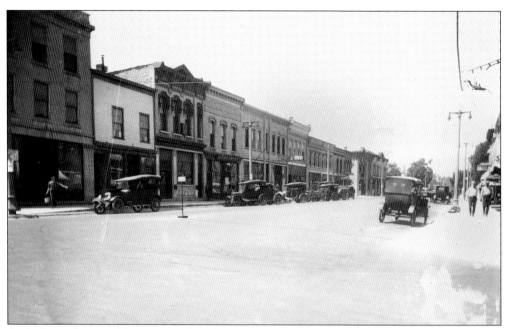

With the explosion of the mass-produced Ford Model T in the 1920s, cars became a regular staple on Main Street. This photograph shows The Hub (center) and looks towards the west side of Main Street. The building to the right (west) of The Hub burned down, and the third building from the left edge of the photograph was renovated into the State Bank of Waupun.

This 1950s photograph of Main Street looking west shows a few of the popular and well-liked businesses of the day. The Waupun State Bank is the third building on the left side of the street, and the Damsteegt Drug Store is two doors down from it. On the right side of Main Street, the second building down held the upscale and well-remembered BonTon Cocktail Lounge.

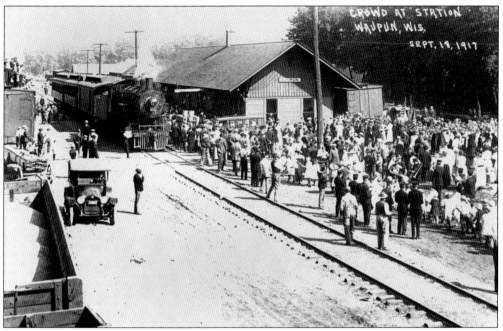

The town of Waupun was alive with excitement on September 18, 1917, as it waited for the orders of the young men being sent off to fight in World War I.

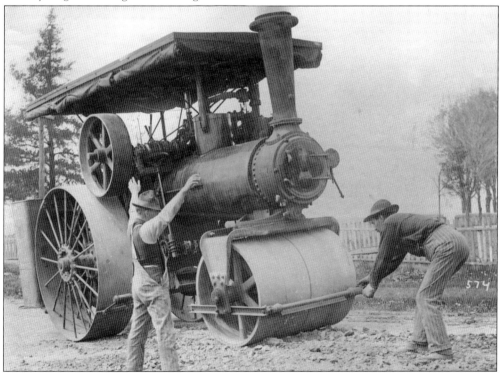

A good-quality infrastructure connecting Waupun to other local towns in the area was paramount to the success of its economy. Here, two men use a steamroller to build the first road connecting Waupun to Chester.

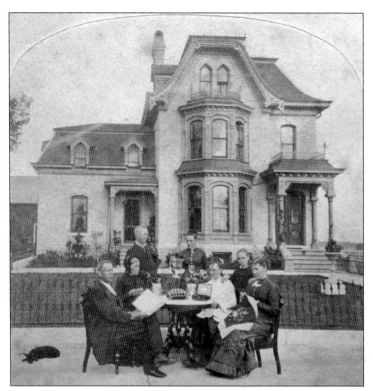

The Dahl House, built in 1879 at 314 Beaver Dam Street, was the first mansion in Waupun. It boasted waterworks, a curved staircase, a ballroom, and detailed ornamental ironwork on the exterior. The home was built by Martin K. Dahl, a blacksmith who moved to Waupun in 1848. Dahl's son Albert became partners with him the same year he built the home. Martin Dahl is seated on the left at the table.

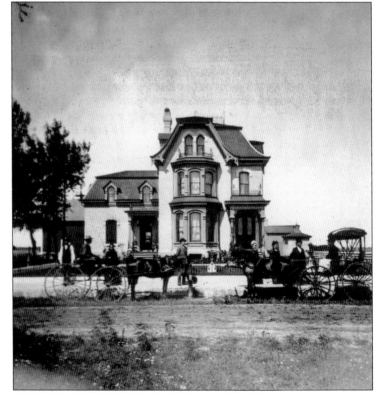

By 1922, the Dahl House fell into disrepair. Dick Rens and his wife worked hard to bring it back to its original splendor. Unfortunately, after being used as a rental, the house again fell on hard times. It was finally saved in 1968 when newlyweds James and Harriet Laird took on the task of restoring the Victorian beauty. It was listed in the National Register of Historic Places in 1975.

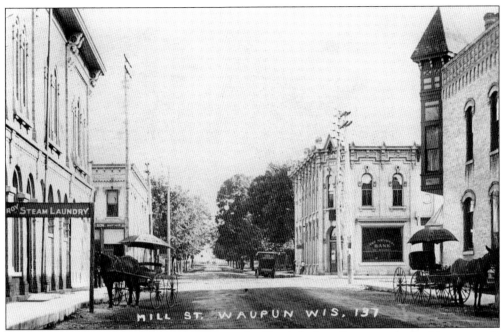

Mill Street is seen here around 1910 from the Fond du Lac County side, looking towards Main Street. The tower perched on the right corner building is no longer there. (Courtesy of Fletcher Studio.)

This group of hardworking laborers takes a photographic opportunity to show off the amount of construction they have accomplished in just nine days. The house they were building still stands today on Madison Street, the first house south of the prison.

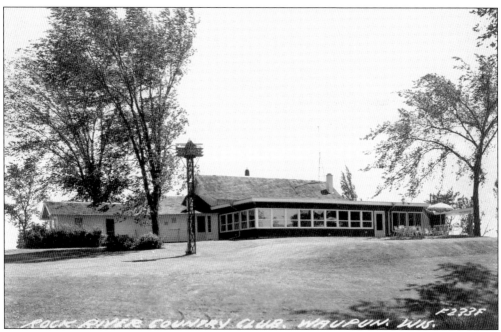

The Rock River Country Club was established in 1927 by prominent businessmen Eli Hooker, Clarence Addison Shaler, Don Newcomb, and Christopher Gerrits. The land was purchased from George Newton to build a clubhouse and a golf course. Shaler commented that the country club was one of his favorite places. To honor the club, Shaler donated a sculpture of a doe and her fawn, which represented the typical nature scene one was likely to witness there.

The original golf course at the Rock River Country Club was built with only nine holes, where the back nine holes are today. The course was updated and lengthened in the early 1980s, and only a few of the original holes remain.

The City of Waupun and Fond du Lac County joined forces to preserve Nathan Newton's woods and create Fond du Lac County Park. The park is on County Road MMM, across from the Rock River Country Club. The Rock River flows through it and there are many hiking trails. Clarence Addison Shaler's sculpture of a doe and her fawn is seen next to the river in this view of the park, taken from the country club.

The Fond du Lac County Pool was a favorite place to swim since its construction during the Great Depression in the mid-1930s. Eventually, problems with the electrical wiring, the leakage of chlorinated water into the Rock River, and the fact that the pool was not deep enough for diving meant that it was unsafe. Fond du Lac County made the decision to close it in 2007.

This large band shell was built at Fond du Lac County Park to host concerts and other entertainment productions. It was also used to protect picnickers in the event of rain. It was eventually knocked down and never replaced.

An early-morning train races across in the background of this beautiful frost-covered scene, taken by Ervin Fletcher of Fletcher Studio. The Harris mill is to the left of the dam, and gravestones in the Forest Mound Cemetery can be seen on the far right. (Courtesy of Fletcher Studio.)

Andreas Dahl, a well-known photographer from Waupun, captured this beautiful view of the prison entrance around 1879. This view, from inside the front walls, now looks completely different after an addition to the front in later years.

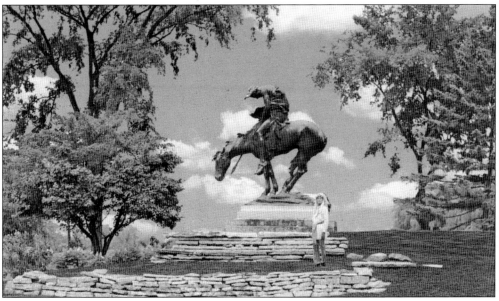

The true identification of the person James Earle Fraser modeled the *End of the Trail* sculpture on has been contested; however, it is widely accepted that Chief John Big Tree, a full-blooded Seneca Indian, was used as the main model. Chief Big Tree is seen here with the statue in 1964 at the age of 86. This photograph was taken by Ervin Fletcher. (Courtesy of Fletcher Studio.)

This nighttime photograph, taken by Ervin Fletcher of Fletcher Studio, captures a passenger train stopped at the Waupun depot in 1946. The train was chartered by International Harvester to pick up farmers in Waupun and surrounding locales to bring them to their convention in Chicago. Ervin Fletcher, a well-known photographer, began the Fletcher Studio with his wife, Edna, in 1942. He has won top honors at state and national competitions, and he did it all with one blind eye. As a young boy, he lost sight in one eye after an accident with a rubber band, but it did not deter him from his passion for photography.

Eight

PASTIME DIVERSIONS

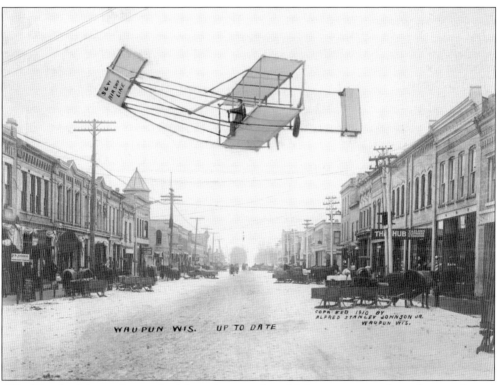

Alfred Stanley Johnson Jr. practiced the unique art of combining two or even three photographs and cutting and pasting them together to make areas appear exaggerated and larger. The combinations created the unusually disproportionate images that made these cards popular. Here is one of Johnson's exaggerations, with a manned glider flying just above Main Street.

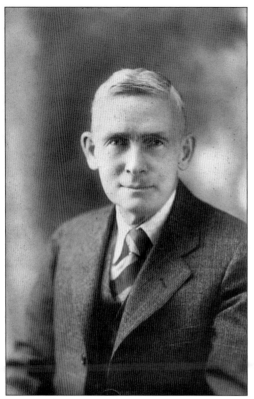

Born in Waupun on January 8, 1863, to Alfred Stanley Johnson Sr. and Elizabeth Johnson, Alfred Stanley Johnson Jr. was best remembered as the creator of some of the most visually interesting and comedic exaggerated tall tale postcards of his time. He began his career apprenticing under his father as a second-generation photographer. The Johnson photography studio was located at 11–17 North Madison Street and is currently owned by Rick Fletcher. For many years, the building was the longest-running photography studio in Wisconsin.

Johnson grew up in a house across the street from the Wisconsin State Prison on South Madison Street. Here, he shows his interest in the Rock River with the comedic postcard entitled "Rock River Carp."

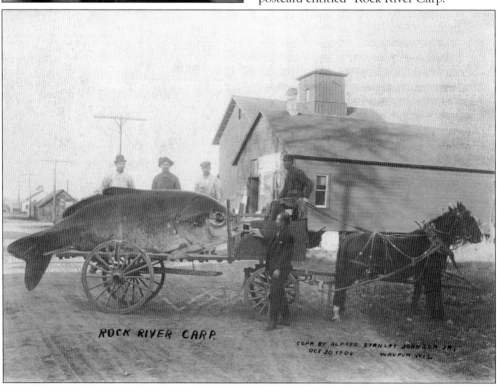

ROCK RIVER CARP.

COPR BY ALFRED STANLEY JOHNSON JR.
OCT 30 1904 WAUPUN WIS.

Alfred Stanley Johnson Jr.'s first wife, Addie Belle Viall, passed away after only two years of marriage. The young widower remarried Myrtle M. Ihde in 1894. In 1909, they had their only child, Alfred "Alfie" Stanley Johnson III, who is seen here with his mother. After Johnson Jr. passed away in 1932, Alfie took over the business for a short time before moving to California with his mother to work on colored film separation in the movie industry.

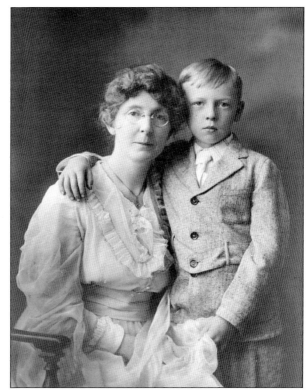

The 1910 census shows that A.S. Johnson Jr. and his wife, "Myrtie" Johnson, were living at 315 North Madison Street with their son Alfred Stanley Johnson III, who was less than a year old at the time. The Boy Scouts–inspired exaggeration below was completed when Alfie was around two and a half years of age.

Here is another exaggeration by Alfred Stanley Johnson Jr. that was inspired by the Rock River in Waupun. His signature and the date of 1913 are seen just above the boat in the background. He signed all his works of art as A.S. Johnson Jr.

Johnson's postcard themes were often agricultural, and nature scenes from Waupun and the surrounding areas inspired him. These topics appealed mostly to farm belt communities and did very well in the Midwest. This postcard is dated 1911, with "Waupun, Wis." written below his signature.

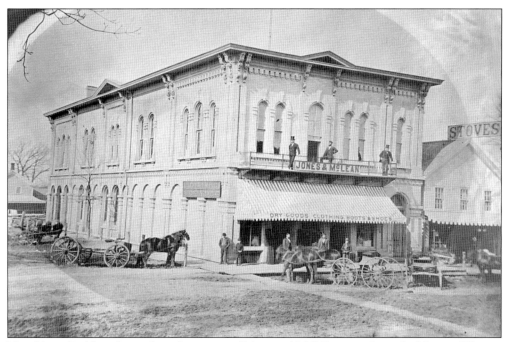

The Oliver Building, located on the corner of Main and Mill Streets, where the House of Hunan is today, was originally built as a 500-seat opera house by Thomas Oliver in 1868. It included a stage and a small balcony, and organizations would put on dances, lectures, and plays there. After the building was sold to Luther Butts in 1876, many different merchants, including Jones & McLean, were located there.

These Waupun children showed their aptitude for innovation when they built this boat in 1914. The majority of the boat was constructed by Les Mielke, Loyd Mielke, and Sam Darling. (Courtesy of Jim Laird.)

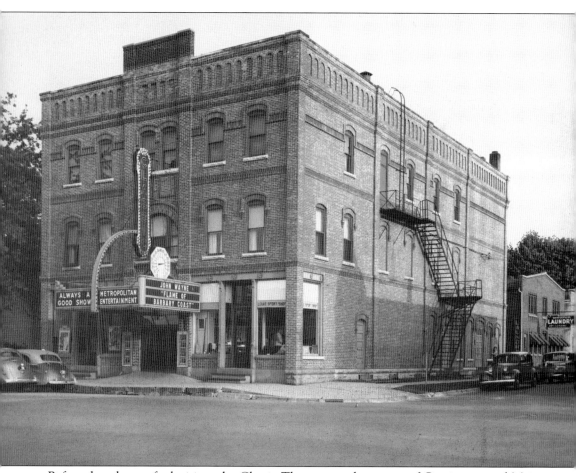

Before the advent of television, the Classic Theatre, on the corner of Carrington and Main Streets, was a popular hangout for moviegoers. Movies starring Charlie Chaplin and Douglas Fairbanks Sr. were popular in the early years, while John Wayne was a favorite in the later years. In June 1962, after losing money steadily because of the popularization of television, the theater was razed and replaced with a gas station. Rick Fletcher is seen here in the background, standing up against the wall to the right rear of the building. (Courtesy of Fletcher Studio.)

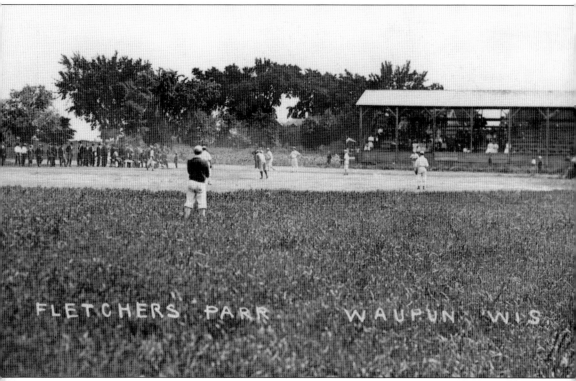

FLETCHERS PARK WAUPUN WIS.

Waupun's own "Field of Dreams" began when Charles Nelson Fletcher moved to town in 1891. Fletcher purchased land for farming, and, soon after arriving, decided to build a grandstand with a horse racing track. In the middle of this track, he created a baseball field he named Fletcher Field. It did not take long before a semiprofessional team, called the Waupun Convicts, was developed. These players practiced daily and drew crowds of 1,500 to 2,000 people for games. In 1898, when the Convicts were scheduled to play Connie Mack's Milwaukee Brewers of the Western League, the whole town shut down except for the train depot, which brought in spectators from all over Wisconsin. Unfortunately, Mack had incorrectly scheduled the date and the Brewers never showed up for the game. To make up for his mistake, Mack donated all proceeds from the rescheduled game to the businesses of Waupun. (Courtesy of Fletcher Studio.)

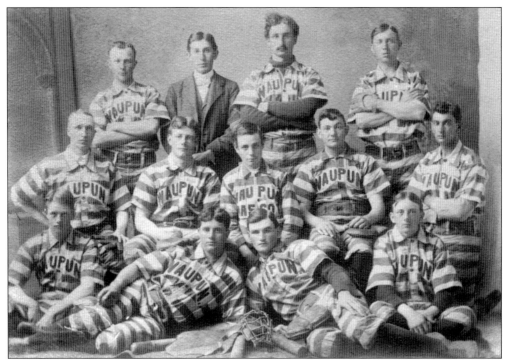

Waupun Convict baseball fans of the day claimed that this 1896 team was the best team they ever had. One of the star players, Clarence "Ginger" Beaumont (second row, second from left), became a well-known center fielder in the major leagues, where he was the first player to score six runs in a game, the first to lead the league in hits for three consecutive years, and the first batter at the first World Series, played in 1903. (Courtesy of Fletcher Studio.)

Before there were lights at baseball diamonds, all games had to be played during the day. This photograph shows the very first nighttime baseball game in Waupun. Ed Marsh is at bat. The photograph is undated, but it appears from the crowd's dress that it occurred sometime in the 1920s.

1924

Best Wishes to Rick Joe Hauser

Joseph John Hauser is pictured here while a major leaguer with the Philadelphia Athletics managed by Connie Mack. Hauser got his big break at age 18 in Waupun when he made the talented, semiprofessional Waupun baseball team in 1917. A year later, he signed with Providence of the Eastern League, where he played for two years before ending up back in his hometown playing for the Milwaukee Brewers of the American Association. He was a favorite of the German immigrant fans, who would yell out, "Das ist unser choe," or, in English, "That's our Joe!" (Courtesy of Fletcher Studio.)

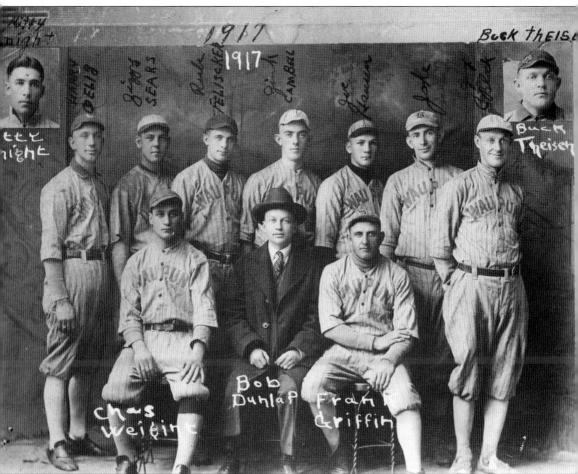

The Waupun Convicts were known for their talent, and it was difficult to earn a spot on the team. In an interview about his early years in baseball, Joe Hauser credited the team for its help in mentoring him and giving him the exposure to be signed into the major leagues. Hauser is seen here in the second row, third from the right. Kitty Knight and Buck Theisen were all-star minor league players who filled in for teams that needed backup players. Bob Dunlap was the team's manager. (Courtesy of Fletcher Studio.)

Mamie Redman grew up in Waupun, where her dad taught her the game of baseball and she fell in love with it. Even though she was not allowed to play or even practice with the high school baseball team, she was good enough for the Milwaukee Brewers' manager, Jake Flower, to recommend her to the All-American Girls Professional Baseball League (AAGPBL), where for seven seasons she experienced the real-life version of the blockbuster film *A League of Their Own*. In 1988, Redman's name was included on a plaque in the National Baseball Hall of Fame and Museum in Cooperstown, New York, where it will remain in a permanent exhibit honoring the AAGPBL. (Right, courtesy of Larry Fritsch Cards LLC, Stevens Point, Wisconsin; below, courtesy of Magdalen "Mamie" Redman.)

MAMIE REDMAN
catcher-utility

Jockey's Greystone Tavern, advertised in this postcard, was a popular local hangout. It was located on Main Street in the old opera building, where the old post office also was at one point.

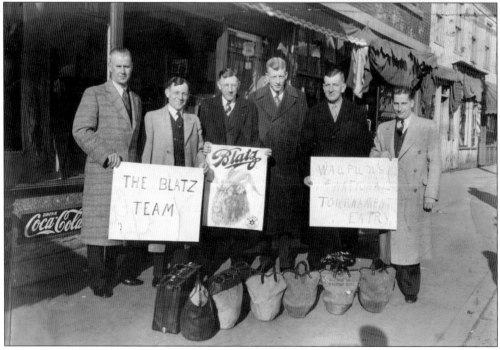

This 1938 Blatz team was the first Waupun bowling team to go to a national tournament in Chicago. The photograph was taken in front of the bowling alley that is Judd's Bowling Alley today. Also visible in the right background is part of what was originally known as the Exchange Hotel, built by Waupun founder Seymour Wilcox. The Exchange Hotel was razed to stop a downtown fire from spreading in 1977. (Courtesy of Fletcher Studio.)

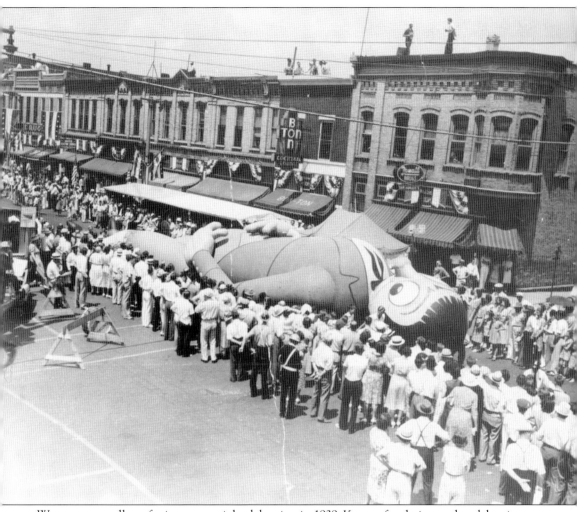

Waupun went all out for its centennial celebration in 1939. Known for their parade celebrations, Waupun natives outdid themselves this time, as enormous, over-the-top rubber-figured balloons were carried down Main Street. This photograph was taken by Val Elster of Elster Sudio, which is now Fletcher Studio. (Courtesy of Fletcher Studio.)

Waupun hosted a huge homecoming celebration for three days in early July 1908. The celebration was centered around the Fourth of July and attracted hundreds of former residents. The estimated attendance was around 5,000 to 6,000 people. A band played at the train depot to welcome guests and there were numerous events for entertainment. A crowd of spectators is seen here awaiting the start of the parade on Main Street.

The evening parade featured decorated automobiles, which were described as "machines" in those days. One report relates that, "Mrs. B. W. Davis was the only woman driving her own machine. It was decorated with red poppies." This Alfred Stanley Johnson Jr. postcard image shows these early machines during the day parade, driving past the old Beaumont Hotel, which was originally the Exchange Hotel.

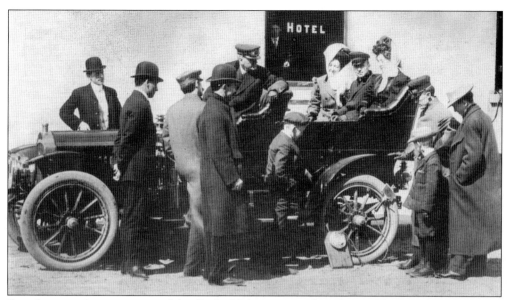

Seen here is a demonstration of the Shaler Vulcanizer patch in front of the Hotel Waupun. Ted Tetslaff, Waupun's police chief at the time, watches the action with a small crowd of people from the front seat of the vehicle. Tetslaff never had a driver's license of his own, even though he was charged with issuing them to those who applied for one.

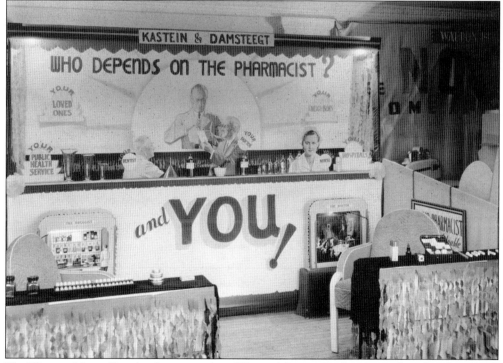

The Waupun Home Show has been a staple in Waupun's history. In the 1940s, when this photograph was taken, it was held in the city hall. Today, the show is located in the community center, which holds most of Waupun's major events and also features an indoor ice rink in the winter months. This booth was set out by the Kastien & Damstreegt Drug Store.

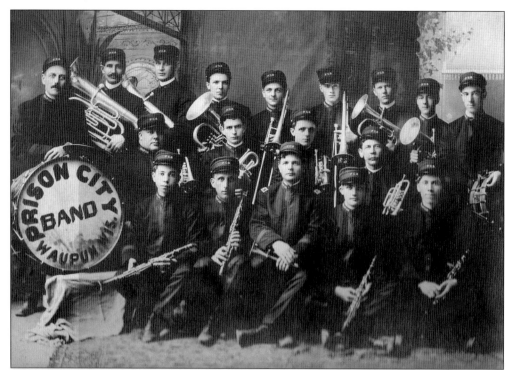

Music has played its own important role in Waupun's history. A popular band from the 1880s to the early 1900s was the Prison City Band, which developed from the Silver Cornet Band of earlier years and was first directed by David Boudry. They reportedly wore splendid dark-green uniforms and played both during the day and in the evenings for summer concerts.

Dutch culture has been celebrated in Waupun since the first Dutch settlements in the late 1800s. For many years, a celebration by the name of Klompenfest was a yearly event in which Waupun citizens could celebrate Dutch heritage. A parade took place where young girls wearing wooden shoes would dance down Main Street. Here, young children perform an operetta called *Tulip Time* in 1928. (Courtesy of Jim Laird.)

The Society Belles of Waupun are seen here around 1890. They are, from top to bottom, Mabel Carrington Faust, Cassie Germain Hall, Blanche Cross Loomans, and Mabel Johns.

Below, members of Waupun Boy Scout Troop No. 11 practices their survival skills while preparing this campfire in the woods in 1938.

DISCOVER THOUSANDS OF LOCAL HISTORY BOOKS
FEATURING MILLIONS OF VINTAGE IMAGES

Arcadia Publishing, the leading local history publisher in the United States, is committed to making history accessible and meaningful through publishing books that celebrate and preserve the heritage of America's people and places.

Find more books like this at
www.arcadiapublishing.com

Search for your hometown history, your old stomping grounds, and even your favorite sports team.

Consistent with our mission to preserve history on a local level, this book was printed in South Carolina on American-made paper and manufactured entirely in the United States. Products carrying the accredited Forest Stewardship Council (FSC) label are printed on 100 percent FSC-certified paper.

MADE IN THE
USA